a comprehensive guide to digital black & white photography

AVA Publishing SA
Switzerland

An AVA Book
Published by AVA Publishing SA
Chemin de la Joilette 2
Case postale 96
1000 Lausanne 6
Switzerland
Tel: +41 786 005 109
Email: enquiries@avabooks.ch

Distributed by Thames and Hudson
(ex-North America)
181a High Holborn
London WC1V 7QX
Tel: +44 20 7845 5000
Fax: +44 20 7845 5055
Email: sales@thameshudson.co.uk
www.thamesandhudson.com

Distributed by Sterling Publishing Co., Inc.
in the USA
387 Park Avenue South
New York, NY 10016-8810
Tel: +1 212 532 7160
Fax: +1 212 213 2495
www.sterlingpub.com

in Canada
Sterling Publishing
c/o Canadian Manda Group
One Atlantic Avenue, Suite 105
Toronto, Ontario M6K 3E7

English Language Support Office
AVA Publishing (UK) Ltd.
Tel: +44 1903 204 455
Email: enquiries@avabooks.co.uk

ISBN 2-88479-056-X

10 9 8 7 6 5 4 3 2 1

Design: Bruce Aiken
Picture research: Sarah Jameson

Production and separations by
AVA Book Production Pte. Ltd., Singapore
Tel: +65 6334 8173
Fax: +65 6334 0752
Email: production@avabooks.com.sg

a comprehensive guide to digital black & white photography

john clements

contents

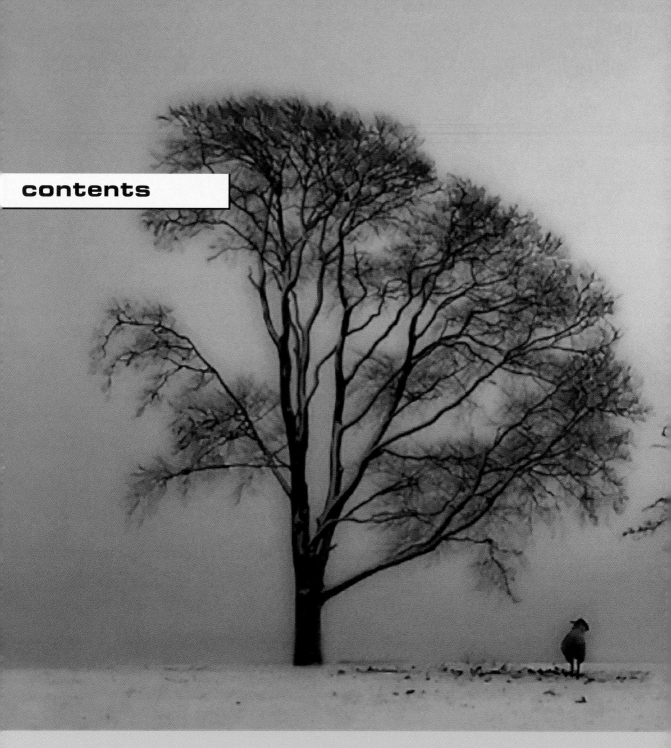

'Sheep and trees' by Miguel Lasa.

introduction

Black-and-white photography is an unique art, something special that takes time to master. That's not to say it cannot be quick to produce eye-catching monochrome images, because it can. Regardless of your aspirations, this book specialises in the subject, and will, I am sure, prove itself as a valuable reference and inspiration.

Monochrome allows artistic statements to be made that are difficult, if not impossible in colour. Few painters have worked solely in these colours, let alone with shades of grey. As such black-and-white photography stands alone, a 'one of a kind' art form and method of communication. Now, in the age of digital imaging it is taking its next logical evolutionary steps.

This guide takes a detailed look at the world of digital monochrome; where we are and suggestions about where we are going. For some, black-and-white imagery will be an occasional route followed, for others it's a constant passion. All interests are covered and many of the useful tips can also be applied to colour work.

Regardless of capturing digital or analogue images, once in computer we have at our disposal more creative and technical control than ever before. The great photographers – famous for their monochrome work in times past – would only be envious. The digital darkroom is an amazing place, and we look in detail at the many paths that can be followed, using examples from some of today's top practitioners. I hope you enjoy the journey with us.

Best wishes and good luck with your photography.

John Clements

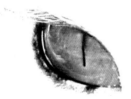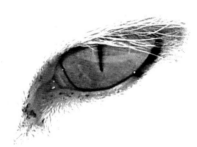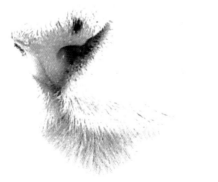

'Catbeard' was created by Wernher Swiegers from a cropped JPEG out of a digital camera. The image was taken into Photoshop and converted to greyscale, then cropped around the eyes and nose. brightness (+65) and contrast (+75) were boosted to fade out the unwanted lighter parts of the face and to enhance contrast of the nose and eyes. Unwanted remaining hairs and whiskers were removed using the clone tool.

shoot – enhance – enjoy

Each spread is divided into the sections 'shoot', 'enhance' and 'enjoy'. 'Shoot' explains the background details up until the moment of capture. The choice of equipment and the context of the shoot are revealed. The 'enhance' section explains the process that the image has been through once in computer, outlining the stunning results that the digital photographer can create post-capture. The 'enjoy' section reveals how the image has been used for personal enjoyment or professional use.

screengrabs

Often detailing the exact settings used for key stages of the photo-editing process, screengrabs make a quick and instructive visual check with which to follow the proceedings.

how to get the most from this book

quotations

The photographer adds his or her own thoughts in his or her own words.

'Monochrome can communicate better than colour in some images. With digital manipulation the effect can be even better.'

1/ The original image.
2/ Size was adjusted via free transform.
3/ The layer blend option is very flexible for fine-tuning effects.
4/ The final image.

shaping your image

shoot

Although Miguel uses a 6Mp digital SLR for most of his photography, a digital compact was used for this shot. The exposure was made at 1/250th sec at f/4.5. 'Walking' was taken in Hartlepool Park, near where he lives. This particular misty morning instigated a rush to the park to capture the image; as a result he was ten minutes' late for work that morning.

introduction

An overview of the theme and techniques set out in the spread.

Digital artist Miguel Lasa has the optimistic attitude of all good outdoor photographers, passionate enough about their art. They go out in less than comfortable situations to nail a significant shot. The rewards will occasionally be images that have a serene feel with few other people around, already well on the way to being 'moody' shots before post-production.

enhance

Miguel likes to give his images an artistic mood to communicate with the viewer. This can take up to two hours during post-production, using Photoshop and a host of plug-in filters. In the case of 'Walking' he used a plug-in called Dreamy Photo by AutoFx. First it was applied to the original image after a small amount of cropping and using free transform via Select > Select All > Free Transform to adjust size (2).

Within the menu options of Dreamy Photo, Miguel set the active colour to white to get the mood required. The filter produces a top layer of effect that was blended with the original using screen mode at opacity of 42 (3). After applying the filter, the image was desaturated in Photoshop via Image > Adjustments > Desaturate and the filter applied for a second time using a separate layer. This time it was blended in normal mode at an opacity of 31.

2 free transform

3 layer blend

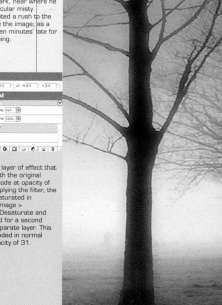

flow chart

A step-by-step outline of the main stages that the image has gone through is given in a flow chart. This allows a quick reference to the same or similar points of interest on different spreads. The flow chart also enables the reader to determine at a glance how simple or complex an image was to create.

> digital capture
> JPEG file
> Photoshop
> Dreamy Photo plug-in
> free transform
> Dreamy Photo plug-in
> layer blend
> desaturate
> layer blend

52 digital darkroom basics

section title

captions

The image captions clarify and recap the processes shown in each image.

images

The images in this book feature popular subjects such as landscapes, portraits, nudes and still lifes. We also showcase the ever-expanding genre of 'conceptual' images. All these types of subject matter have their place in modern image-making, and, from the traditional to the surreal, there are examples of images for people of all tastes to appreciate.

! *Free Transform* gives lots of control when it comes to adjusting the shape of an image. It transforms an image or selection to re-scale as in 'Walking'. It can skew, rotate or change perspective of an image. It works without having to make more time-consuming adjustments through other means. Various key commands change the type of adjustment, while settings can also be typed in such as a degree of rotation. A useful re-scaling can be achieved by holding the shift key down while adjusting a drag handle. This re-scales the shot and keeps it in proportion to the starting dimensions. But you must select the area you wish to change first.

enjoy

Miguel makes prints for his own enjoyment and occasionally sells his work to friends.

tips

Practical tips from the author and photographer allow the reader to apply issues raised in the images discussed to his or her own creative work.

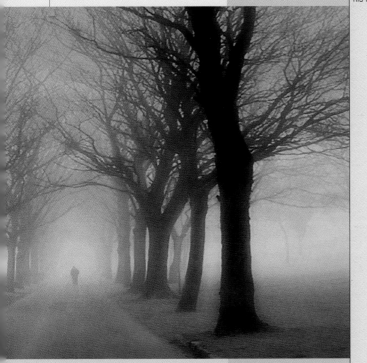

shaping your image **53**

spread title

1 digital monochrome

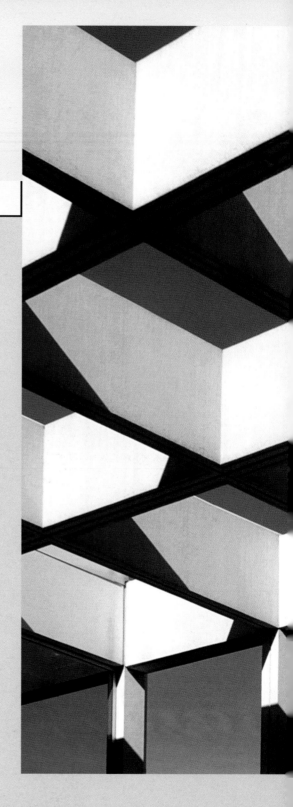

'Through the Roof' by Heather McFarland.

This graphic image was created using a
professional digital SLR fitted with a 35–70mm
F2.8 lens. When Heather finds a scene where
strong contrasts and graphical lines are the
main elements, she often prefers to use
monochrome as it can produce a more striking
image.

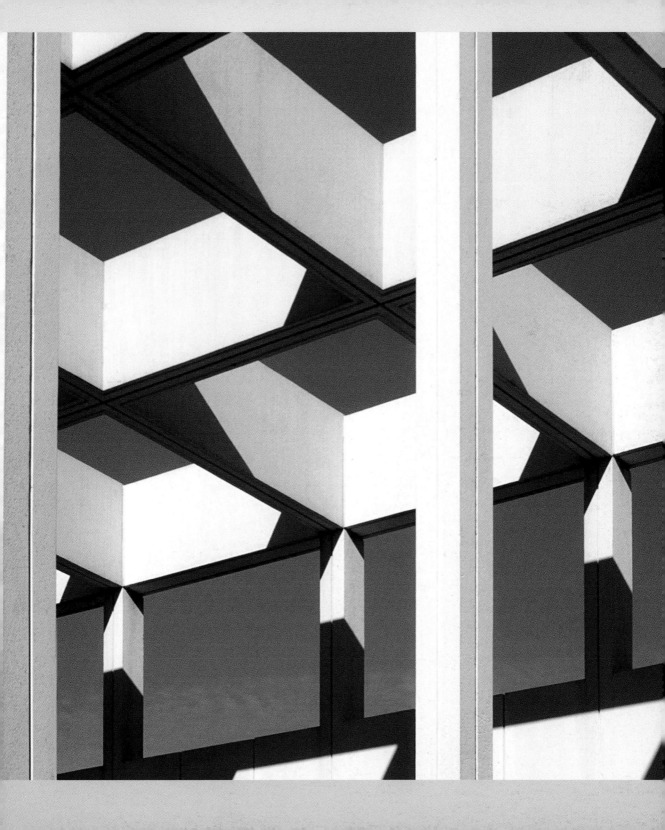

in this chapter

In this chapter we take a look at a few samples of the many ways different photographers tackle their monochrome digital imaging. From the simple to the advanced, the route you take can be varied and flexible.

monochrome world

Here we introduce the more common digital methods of creating black-and-white images. We examine in-camera monochrome modes, to removing colour post-capture in the computer.

pages 14–15

the art of seeing

Some subjects just call out for a colourless image. Here we look at the style one photographer uses for architecture, a popular subject for black-and-white devotees.

pages 16–17

splitting channels

After the more common options there are numerous other ways to create a monochrome image from colour originals. Here a less used, more advanced method of splitting colour into component channels is used as an alternative.

pages 18–19

calculating command

Carrying on the theme of advanced but less often used conversions from colour, we now examine the flexibility of using the calculations command in Photoshop.

pages 20–21

the channel mixer

A very flexible way not only to create black-and-white images, but also reintroduce simple toning is looked at in this spread. The channel mixer is appreciated by many who regularly work with mono imagery.

pages 22–23

'I am most drawn to images with strong lines and graphic appeal. Many of these types of image lend themselves well to conversion to monochrome as the lines and shapes are the most important feature of the image.'

1/ Heather's image entitled 'End Of Tunnel'.

2/ Many cameras offer a black-and-white capture mode. John Clements supplemented it here by adding noise to the sky in Photoshop.

3/ A simple way to tone a mono image is to use hue/saturation and the colorize option.

monochrome world

There are many ways to create a black-and-white image: in camera, on film or during post-production back at base in computer. What suits you best depends on your personal circumstance. Here we outline the more common routes photographers take, so you may even find a better way than you already use. However, this chapter also looks further into the issue and really tackles the route to mono.

1

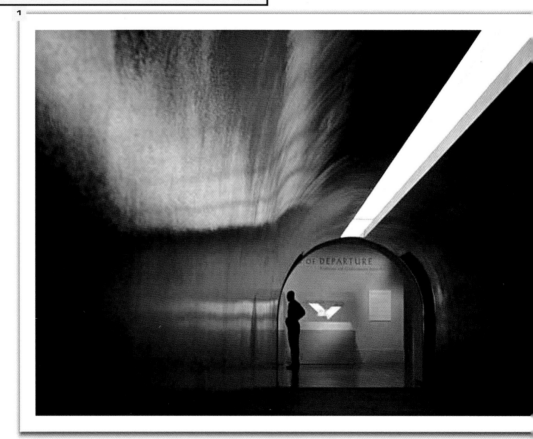

Heather McFarland is a professional photographer based in the USA. This image, 'End Of Tunnel' (1), was created using a compact camera with an exposure of 1/7th sec at f2.7 and a compensation of EV-0.7. She liked how the row of lights in the ceiling drew the eye down the tunnel to the opening at the other end. However, it needed a little something else to make it work fully so Heather waited for someone to appear in the tunnel before she took the shot. This gave a focal point and a reference for scale. Post-capture the colour image was converted to black and white via Image > Mode > Adjustments > Greyscale. Heather sells prints online via her Website and has work with several local fine art dealers.

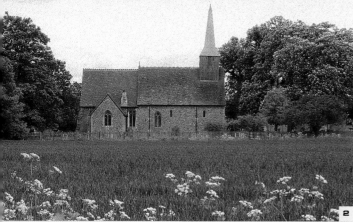

2

3 clone tool

shoot

Some digital cameras have no black-and-white capture mode. That's a shame, but not a disaster as colour, as we see throughout this book, can be removed post-capture easily enough. All cameras technically capture in monochrome. Brightness values are created from an analogue signal when light passes through red, green and blue filters or occasionally through cyan, yellow, magenta and black. These are turned into a digital code for each filtered colour, and then software interprets the values and recreates a colour image. Technically therefore, any camera's basic brightness data can be processed for its monochrome values only. If your camera has a black-and-white mode, that is what happens. If not, shoot a full colour image and strip this aspect out in computer at a later date.

enhance

The most obvious way to remove colour from an image – be that digitally captured or with a scanned film original – is to take the colour out completely. That's what greyscale mode in Photoshop or similar programs does via Image > Mode > Greyscale. This is permanent so should be done with thought, but it makes for one easy step to mono. The other advantage is that by throwing away colour detail and just keeping greyscale values, the file size shrinks. Typically you end up with an image only around 1/3rd its original megabyte (Mb) size. However, loosing the colour information can be a disadvantage even for a mono shot. Greyscale uses a range of 256 brightness levels between white (255) and black (0).

Desaturate > Image > Adjustments > Desaturate, also creates a greyscale

image, but strips the colour out rather than throwing it away. This means that the file size does not change. The effect can be reproduced in Photoshop by utilising the hue/saturation option (Image > Adjustments > Hue/Saturation) and setting saturation to -100 in Photoshop. However, if you check the colorize box, then using the sliding controls, you can adjust the tone of your monochrome image (3).

! Some cameras have a black-and-white mode. This works in a similar way to a greyscale image in Photoshop. John Clements modified this shot (2) by adding some noise to an otherwise white sky for effect within that program.

Some cameras go further than offering a black-and-white mode. Sepia-toned images are also created, but you may want to compare the results against techniques post-capture that can create the same effect to see what's best.

'When architecture is in question, I have always preferred to capture texture and play of light/shadow over colour.'

! Use the post-capture preview in your camera combined with reading histogram information to judge the best exposure.

1/ The original capture.
2/ The final image.
3/ Light and architecture attract the photographer's eye as the starting point.

the art of seeing

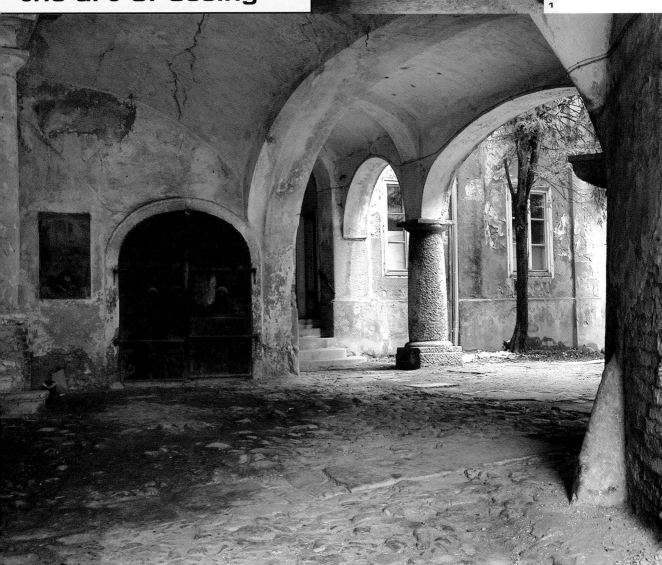

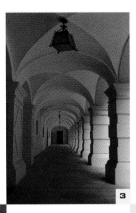

3

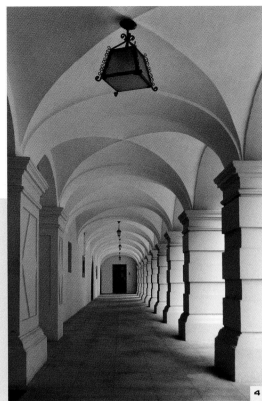

Mirko Sorak is based in Zagreb, Croatia. One of the countless enthusiastic amateur photographers around the globe, he has a passion for architectural images. This kind of subject suits monochrome work, but as with most images, benefits from both considered first exposure and sensible post-production.

shoot

The two images shown here are typical of both considered first exposure and sensible post-production. The first, entitled 'Old Part of Town', was originated using an advanced 5Mp compact digital camera, and a program mode exposure using 100 ISO sensitivity. The second image 'Lamp' was created using a digital SLR with interchangeable lenses, Mirko's preferred camera choice. In this instance an exposure of 1/20th sec at f/4.5 and 200 ISO sensitivity was made, again using programmed exposure control.

4/ The final version of 'Lamp'. About 20 minutes were spent working on this image. As with 'Old Part of Town' it was first converted to greyscale in Paint Shop Pro then a levels adjustment was made to improve contrast. Rotating the image slightly straightened the verticals. The 'clarify' filter was used at a setting of 1 to improve this further. The electrical installation cabinet at the left of the gate was cloned out and finally grain and noise were reduced using Neat Image software.

4

enhance

Mirko uses Paint Shop Pro and Photoshop, but also NeatImage software. 'Old Part of Town' was taken in an old part of Zagreb and lighting was Mirko's main inspiration. About 30 minutes were spent working on the shot post-capture. First it was converted to greyscale using Paint Shop Pro > Colours > Greyscale. The Levels were adjusted to gain more contrast (as is usual practice with virtually all images and software), but also in this instance to slightly lighten the midtones. The contrast was further improved by using the Paint Shop Pro filter 'clarify' at a setting of 1. A new adjustment layer was created and using the hue, saturation, and lightness controls, a sepia tone created. We will look at various ways to do this throughout the book. A final step was to remove the grain and noise using NeatImage.

enjoy

Mirko's work has been displayed in several exhibitions and he also makes prints for his own pleasure.

> digital capture
> JPEG
> Paint Shop Pro
> greyscale
> levels
> clarify filter
> hue/saturation/
 lightness
> sepia tone
> NeatImage
> noise/grain reduction

splitting channels

Dock to Palette
New Channel...
Duplicate Chan
Delete Channel
New Spot Chan
Merge Spot Cha
Channel Options
Split Channels
Merge Channels
Palette Options.

For over a decade Walter Spaeth has been winning prestigious awards. This digital artist and photographer is based in Nehren, Germany. 'Body Art' tackles a traditional monochrome subject but is an example of a slightly less conventional way to get to black and white.

shoot

Using a 3Mp SLR attached with a 100mm f/2 lens, the exposure was made at this wide-open setting. The lighting was strong so this decision had more to do with selective depth of field than maintaining a hand-held camera steady. Using 100 ISO sensitivity, the shutter speed was 1/250th sec. Metering was made from a small central area of the camera's view, but not small enough to be a spot reading. Interestingly the colour original already had a monochromatic influence.

3 red channel

4 blue channel

5 green channel

enhance

Walter uses Photoshop as his software manipulation program and he finds a graphics tablet invaluable in post-production. This image was worked on for around 30 minutes. With your image open, select Window > Channels and clicking the arrow icon takes you to the sub menu to select from (2). For 'Body Art' after examining each channel (3/4/5), it was the green one that Walter kept, discarding the red and blue.

1/ The original file.

2/ The channels palette showing the split channels.

3/4/5/ Splitting an RGB image into its greyscale channels allows assessment of quality to be made.

6/ The final image.

> digital capture
> Photoshop
> channels
> split channel
> TIFF file

! If noise or other artifacts are an issue in a particular image, you could split the channels and throw away those where these are most prominent. For instance, the blue channel in a digitally captured image may have more noise than the red or green. Adjustments afterwards through such things as brightness and contrast and others, can still provide a monochrome image with impact should changes be required.

enjoy

Walter prints out his images using a pigment-based ink jet A3+ printer. These are sold commercially through various Internet gallery sites.

6

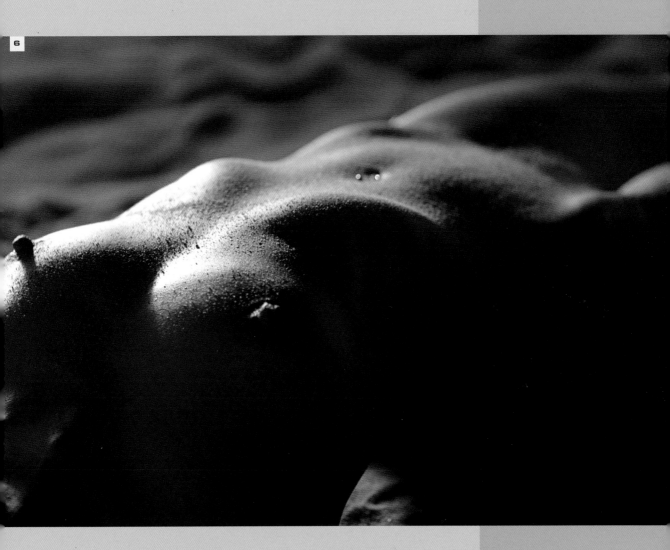

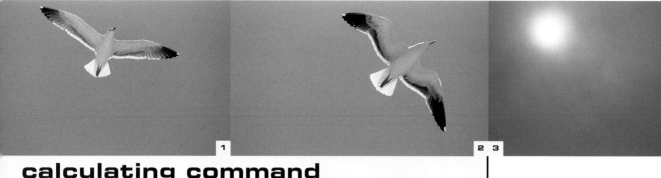

1 2 3

calculating command

Darwin Wiggett and Anita Dammer combine their considerable talents as Natural Moments Photography. As a professional photographer Darwin's work is used in many ways, but particularly as stock imagery. He shoots everything in colour, but uses the digital darkroom to look at the monochrome possibilities. This image shows how to composite images from colour to mono using the calculations command.

shoot

Darwin and Anita mainly create their work on film, mostly using a 6 x 4.5cm camera system, but this image was captured using a professional 35mm camera and 70–200mm f/4 lens. It was loaded with a fine-grained professional film, developed primarily for the social market. This had a 160 ISO rating. The location was Baja, Mexico and the image was captured while on a kayaking holiday. Darwin loved the way the gulls were backlit, but once the results were viewed back at base, they did not have the impact he had visualised.

enhance

The images were scanned using a high-quality film scanner, which accepts all sizes of medium format film and 35mm images. Darwin found within his files an image of the sun as a hazy ball (3). Taking the gull images into Photoshop, the colours were changed so the blue sky in the gull shots was the same colour as the blue sky in the sun shot. A rough selection around each gull was made using the lasso tool. These were dropped over the sun image using layers. The size and placement of each was experimented with until the composition looked right. Next came the blending of the birds into the background shot using layer masks (4). Final adjustment was to turn the colour image into mono. This was achieved by using the calculations command, and blending the red channel with itself at 25% opacity using the multiple blend mode (5). At this stage the gulls were light against a darker toned sky. The image was then turned back into colour and the blue channel selected to enhance the highlights. These were selected and feathered by 20 pixels. Using Image > Adjustments > Hue/Saturation, and setting the colorize option, the sepia tone could be created for the highlights. The settings were 30 (hue) and 25 (saturation). This took around an hour to complete and the result matched what the photographer was thinking drifting in his kayak.

5 calculations command

Source 1:	NMP859A.jpg		OK
Layer:	Background		Cancel
Channel:	Red	☐ Invert	☑ Preview

Source 2:	NMP859A.jpg	
Layer:	Background	
Channel:	Red	☐ Invert

Blending: Multiply
Opacity: 25 %
☐ Mask...

Result: New Channel

> 35mm film capture
> colour adjustment
> lasso tool
> layers
> layer mask
> calculations command
> stock

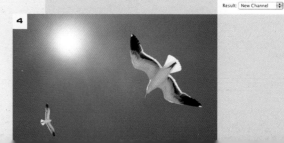

4

'The feeling I had was of a sun-drenched sky and birds circling overhead. That was the image I wanted to create.'

'Like any type of photography, digital is first and foremost about light and understanding light. Technique and manipulation should only work to enhance the mood of the light you captured in camera.'

! *Calculations Command* This is an advanced route to producing monochrome images. The calculations command (Image > Calculations) works on two images and undertakes a calculation (applies a mathematical formula) based on the combination of effects on two pixel values, one from each image. The two pixels are those that correspond in terms of their location (coordinates) within each image. The effect is a combination of the two, applied in a new channel. For this to work the two images must have the same pixel dimensions and be from the same colour model such as **RGB** or **CMYK**. The blending options are not dissimilar to those of layers, but two – add and subtract – are not available on the latter.

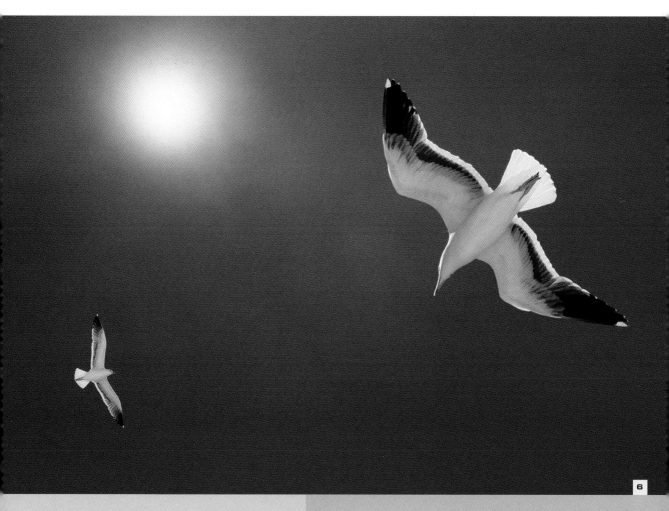

6

1/2/ Original gull images.

3/ A shot from the photographer's files gave the sun ball image.

4/ Birds and sun combined using layer masks.

5/ The calculations command dialog box.

6/ The final image.

enjoy

As mentioned previously, Darwin's efforts are targeted at the stock market. This is a tough arena in which to flourish and calls for a regular supply of new images.

'Be careful with exposure and you'll save a lot of time with the computer.'

1/ The original image.

2/ The channel mixer offers tonal and contrast control as would traditional on-camera filtering.

3/ The final image.

the channel mixer

One of the most flexible ways to convert an image from colour to mono, and then adjust its tones and contrast, is to use the channel mixer in Photoshop. This is an often-overlooked option but it combines flexibility with ease of use.

shoot

'Road on Mars' was created by Felipe Rodriguez, a very talented amateur and enthusiast photographer. He is based in Seville, Spain. This picture was taken with a 15–30mm zoom lens at its widest angle on a professional 6Mp digital camera. The sensor's size made this equivalent to a 22.5mm lens on a full frame sensor so still markedly a wide angle. The lighting levels made it possible to use a 1/1000th sec exposure at f8, with 200 ISO sensitivity. Monochrome has a special appeal to Felipe, citing Ansel Adams, Cartier-Bresson and Robert Capa as his inspiration. This image began a series of photographs taken at and around the Río Tinto abandoned mine, a really 'stunning spot'. He went there on a nice, but partially cloudy autumn day and this shot was taken with the open mine in view along an approach road. The camera's centre-weighted metering system was used in preference to the multi pattern or spot methods, and was ideal with such a wide tonal range to capture.

enhance

Most people who comment on his work suggest it is 'minimalist' and Felipe agrees with them that 'less is more (almost always)'. Taking the JPEG file into Photoshop, he used the channel mixer. This can be selected either by Image > Adjustments > Channel Mixer, or as in this instance via Layer > New Adjustment Layer > Channel Mixer. It is a wonderful way to control effects for mono as well as colour images. Felipe thought that such a cloudy sky could also work very well in mono by adjusting mostly the red channel. This he increased by 150%, combined with a reduction to the blue and green channels to -25%. The effect was created on a separate layer rather than the original. The image was finally saved as a 300dpi CMYK TIFF file (23Mb), with a Euroscale Coated v2 profile embedded for use in this book.

2 channel mixer

Output Channel: Gray		OK
Source Channels		Cancel
Red:	+150 %	Load...
Green:	-25 %	Save...
Blue:	-25 %	☑ Preview
Constant:	0 %	
☑ Monochrome		

> digital capture
> JPEG
> Photoshop
> new adjustment layer
> channel mixer
> CMYK TIFF

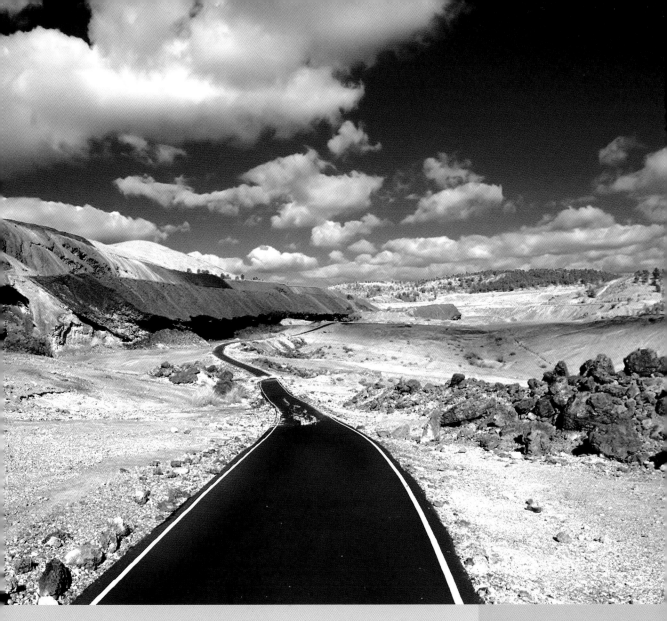

! As a guide, an RGB mono image often looks best when channel mixer values add up to around 100%.

! *Channel Mixer* Working with colour or mono effects, this control is very versatile. Open an RGB or CMYK image and go to Image > Mode in Photoshop, and check the monochrome box. Colour is taken out but not destroyed, unlike using the simpler greyscale mode conversion via Image > Mode > Greyscale. This allows contrast changes to be made, similar in effect to traditional on-camera filtering. Wonderful. It works in percentage values, based on how much ink is used to print a grayscale image. Black is zero and white is 100%. As an added extra, if you uncheck the monochrome box, the image remains greyscale, but by now adjusting the colour sliders toning can be created, but is best used with subtle adjustments.

enjoy

Sometimes people request a picture to buy, but most of Felipe's work is for his own enjoyment. He has however had a lot of his work published.

2 digital capture

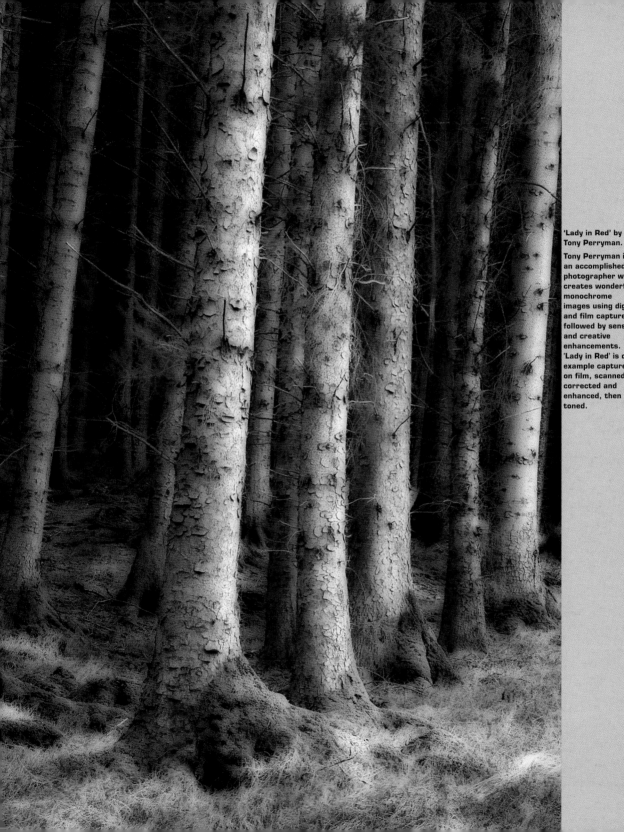

'Lady in Red' by Tony Perryman.

Tony Perryman is an accomplished photographer who creates wonderful monochrome images using digital and film capture, followed by sensible and creative enhancements. 'Lady in Red' is one example captured on film, scanned, corrected and enhanced, then toned.

in this chapter

This chapter looks at creating and defining digital images into the popular file formats, detailing the advantages of each. It then moves on to getting the basics of exposure right.

file formats

A JPEG file is the most commonly used file format, enabling data to be compressed for small file sizes and fast writing times in camera. A TIFF file in comparison is sought for its stability and the detailed information it contains, and is better suited to higher quality reproduction.

pages 28–29

digitising film

Film originals offer the photographer a high quality capture route to monochrome. Here we look at film scanning, how to get the best from it and how to maximise the technical potential of the original.

pages 30–33

getting exposure right

The best digital workflow starts with optimum exposure in camera. If that is not the case, many things can be corrected or 'saved', but you will not obtain the best potential quality unless you start as you mean to go on.

pages 34–37

the digital negative

A RAW file is the ultimate in flexibility and holds the maximum potential quality. It is like having a film negative that you can reprint as many times as you like but in different ways if you wish. Here we look at the priceless quality that is a RAW file.

pages 38–41

1

Compression takes place each time the file is 'Saved', but this cumulative process degrades the file each time. It is important to use the 'Save As' command instead to avoid the cumulative effect. By choosing the optimum compression ratio, we capture enough detail for specific needs, fast writing to storage, and keep the file size down. For instance, minimum compression – often called fine,

file formats

There are a number of options when it comes to saving and using digital images. They exist in a number of 'file formats' each with strengths and weaknesses. The right choice depends on your style of photography and how the end product will be used.

2

> digital capture
> **JPEG** file
> Photoshop
> channel mixer
> crop
> levels
> **CMYK TIFF** file

super fine or large – creates a file suitable for moderate enlargement prints. Alternatively a higher compression such as 'basic', is useful if going straight to Web. However, if possible, always save the highest quality and work back from there. If you output via a high street lab, the machinery used can find it easier to recognise a **JPEG** file than any other.

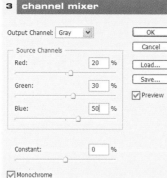

3 channel mixer

Output Channel: Gray

Source Channels

Red: 20 %

Green: 30 %

Blue: 50 %

Constant: 0 %

☑ Monochrome

OK
Cancel
Load...
Save...
☑ Preview

! If you only shoot **JPEG** files it is best to save the intact original and make a copy of it to work on.

! Once you are sure that the **JPEG** copy you have worked on is finalised, save that file as a **TIFF** file for stability.

! *Stable Option* Many cameras enable a **TIFF** file to be created from the **RAW** data in camera. Most image manipulation programs can read this 'Tagged Image File Format' and it is the best quality out of camera. A **TIFF** file is large in Mb terms, the data is not usually compressed. This is desirable for reproduction in magazine and book form, and other commercial printing requirements such as calendars and greetings cards. The extra information is necessary to reproduce a good quality image with a smooth continuous tone as the image is taken through various stages of reproduction. But you won't necessarily see this with prints via desktop printers. The downside is the amount of storage space taken up, plus the time to write data and move it around. **TIFF** file stability is not affected by repeated saving. Most people work with RGB (red, green, blue) **TIFF** files, but some people who are sending work for reproduction will provide **CMYK** (cyan, yellow, magenta, black) files instead. If in doubt, supply the former, as many print reproduction companies prefer to do their own **RGB** to **CMYK** conversion.

4 cropping the image

1/ The original image.

2/ The final image, 'Shapes', by Felipe Rodriguez.

3/ The channel mixer was used to convert the image into black and white.

4/ Felipe completed the image with a slight crop.

shoot

The basic data a camera's sensor and software produce after exposure is in 'RAW' form. Initially unprocessed, internal software 'develops' the digital image, writes this to storage card, or uploads direct to computer. RAW data can remain 'unprocessed' and manipulated from this point when a 'RAW' file is taken into compatible software post-capture. This 'digital negative' is as priceless as any film equivalent. Maximum potential comes from this option. However, the alternatives of either a JPEG or TIFF file are more commonly used, and do not require in theory at least, as much post-production time. For 'Shapes' Felipe Rodriguez captured a JPEG file. This balustrade showed the effect of backlighting and he loved the geometric pattern.

enhance

The channel mixer in Photoshop was used to convert the image into black and white (3). As image contrast was important, mainly the blue channel was adjusted. However, you should be careful with this channel as it has more noise than the red and the green. The image was followed by minor levels adjustment, Image > Adjustments > Levels, and cropped slightly (4).

enjoy

The image was saved and provided as a 300dpi CMYK file for use in this book.

'I love images which capture abstraction, particularly by focusing on the detail of urban environments and lifestyles.'

! While dedicated film scanners can tackle many tasks automatically, some aspects are better taken off auto and adjusted manually if you have time.

! While many effects and adjustments can also be achieved in your image-editing program, technically it is best to do much of this at the scan stage. Start off with quality!

digitising film

Scanning film and turning its analogue values into digital ones is an important craft. There exists a wealth of images created before digital capture became common which cannot be forgotten. Also, the unique and often desirable qualities that modern-day films possess can be very useful. Drum scanners represent the top end of quality, but their price is beyond most people's budget. However, suitable quality for most eventualities can today be obtained by using a desktop unit with attention to detail.

scan

Work backwards. That's a good way to think about scanning. It is best to set the dpi (dots per inch) or resolution and the resulting file size desired with the final use in mind. If you don't know what that might be, then future proof your scanning time by creating a high quality file of sensible size. If the final file is too large, you have spent time creating data that then has to be thrown away later in the workflow and it will swallow up storage space. But do not opt for too small an image unless looking only to place the image on the Web or for uses that require low quality images.

enhance

Scanners take a short time to warm up, but after that, an initial pre-scan can be made at a low resolution. Shown as a preview it can generally be adjusted in size. This allows a crop of the image, losing any non-essential areas around the edges, or even better, into only those parts of the image you are certain of using. The dynamic (tonal) range can be controlled through such tools as an adjustment through reading the histogram and using a levels control or similar, or by setting single black-and-white points to expand or contract the range. This will give the desired shadow to highlight tonal reproduction. The midtones can generally be adjusted also. Once you are happy with the way the pre-scan looks, make your final scan. Many photographers use dust and

scratch removal software if that is available. This can be a valuable time-saving tool, avoiding, to a greater or lesser degree, retouching later. The best scanners offer control over this but it can soften the image. Unsharp Mask (USM) may be needed later in the workflow to counteract this. Another time saver is to use a 35mm film scanner, one that allows batch scanning. Usually an optional accessory, this simplifies your workflow, especially with images shot under the same conditions such as in a studio with controlled lighting. Old and faded film can be made more acceptable by using colour restoration software even if you then transform it to monochrome later. Included within many of the scanner software options, batch scanning like dust and scratch removal significantly increases the scan time.

> warm-up

> pre-scan

> crop

> dynamic range

> RGB/CMYK file

> scan

> dust/scratches removal

> TIFF file

1 automatic options

▼ Digital ICE4 Advanced

☑ Enable Digital ICE On (Fine)

☑ Enable Post Processing

Digital ROC ◄――――――――○―――――――► 5

Digital GEM ◄―――――――――○――――► 3

☑ Enable Digital DEE

Shadow Adjustment

◄――――――――○――――► 50

More>> Redraw

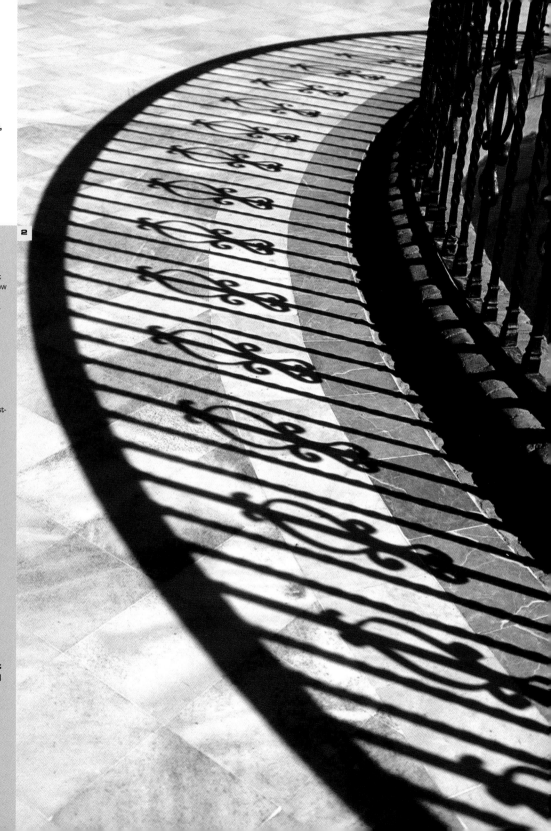

2

1/ Automatic options like dust and scratch removal or shadow enhancement can be a major benefit in the overall workflow.

2/ 'Light and Shadow; Parque de Maria Luisa, Seville' was created by Jon Bower. Initially shot on 35mm professional slide film with a +0.5 EV adjustment, this image was scanned at 4000dpi using a 35mm desktop scanner. Jon prefers to do most of his adjustments in Photoshop post-scan. He supplies his stock clients the reworked digital image. The image was de-spotted, then converted to mono with channel mixer. A small final adjustment with curves and levels was made.

These were the settings used to scan this image

Nikon SUPER COOLSCAN 8000 ED	Digital ROC: 0.00 Analog Gain Master: 0.00 EV
2001/09/13 13:06:56	Digital GEM: 0.00 Analog Gain Red: 0.00 EV
Film Type: Positive	Digital ICE: Normal Analog Gain Green: 0.00 EV
Image Size: 2400 x 3500	Multi Sample: 1x Analog Gain Blue: 0.00 EV
Color Space: RGB	
Scan Bit Depth: 8	

Scan Data

! **16-Bit & 8-Bit Data** Bit depth refers to the range of colours (or tones) recorded. 8-bit files are the normal default. This is more than enough for many end uses, but for maximum quality and output potential, 16-bit files may be preferable. This can be particularly useful if you are looking to output in magazine or book form, or for high quality photographic print output. Extra shadow detail is in theory extractable, even if the image is reduced back to an 8-bit file before output.

1/ As with a digital camera's Exif data (this is the recorded shooting data for the settings used), many scanner software packages allow the settings used to be seen. This image shot by John Clements started life as a 35mm original. The final scan was 25Mb.

2/3/ If you want to produce a final file ready for print, many aspects of post-production can be achieved in the best scanner software options. Here colour balance and contrast were changed.

3 colour balance

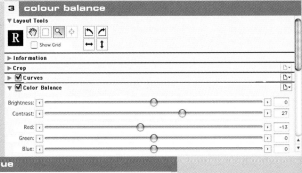

▶ **Layout Tools**

☐ Show Grid

▶ **Information**
▶ **Crop**
▶ ☑ **Curves**
▼ ☑ **Color Balance**

Brightness:	◀ ─────●───── ▶	0
Contrast:	◀ ─────●──●── ▶	27
Red:	◀ ────●──────── ▶	-13
Green:	◀ ───────●─── ▶	0
Blue:	◀ ──────●──── ▶	0

4 curves adjustment

☐ Show Grid

▶ **Information**
▶ **Crop**
▼ ☑ **Curves**

RGB

255

39 | 1.00 | 241

0

Input: 154 | Output: 108

5 adjusting hue

▶ **Information**
▶ **Crop**
▶ ☑ **Curves**
▶ ☑ **Color Balance**
▶ ☑ **Unsharp Mask**
▼ ☑ **LCH Editor**

Hue

Input: 251 | Output: 291

4/ Curves adjustment can be carried out globally or for specific colour channels.

5/ Some packages have lightness, hue and saturation mode. This is for many easier to work with than adjusting an RGB or CMYK image as it seems more instinctive. In monochrome it will adjust the tonal range.

enjoy

An image, unless there is good reason not to, is best saved first as a TIFF file for stability. If you need a smaller file, convert to a JPEG afterwards, but archive the TIFF option. Regardless of the file format, a file saved in red, green, blue (RGB) values will be smaller than a cyan, magenta, yellow and black (CMYK) file. You can always convert the image to CMYK later.

6/7/8/ Various tones were applied to the image, the final has a warm golden feel that suited the image best.

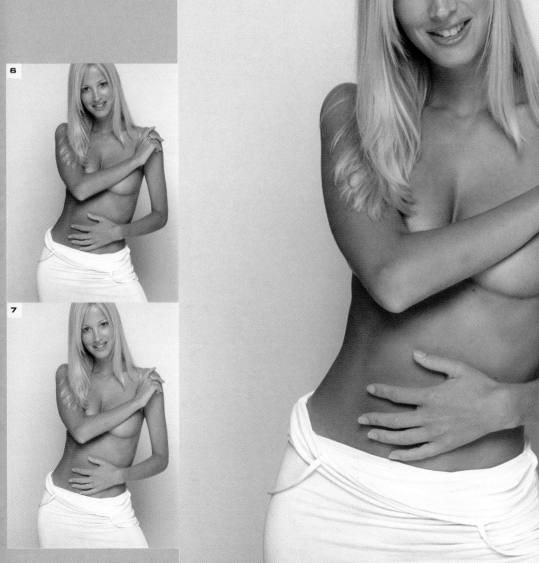

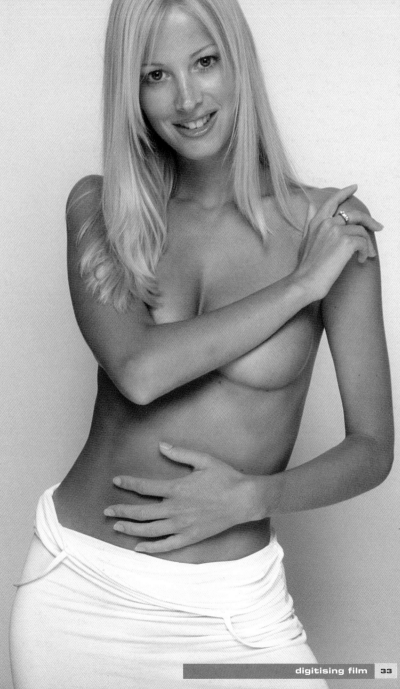

1

! **The Histogram** Rather than viewing an **LCD** image played back on a digital camera, a better indication of exposure comes from its histogram. It is easier to see under many situations. Comprising of a scale, the left to right axis shows the brightness values from shadows to highlights with midtones in between. The vertical axis shows the number of pixels recorded at

getting exposure right

Keen amateur photographer Phil Preston is based in Aylesbury, UK. His images have been published widely. However, the flexibility of his chosen manipulation program **PhotoImpact**, or others of this type, is best used only after getting the best possible start. That means correct exposure in camera. Digital capture is similar to exposing slide film and as a guide, highlights should be exposed at their best, with the detail you want captured contained within, rather than being 'burnt out'. Afterwards, during post-production, you can process to reveal shadow detail for the widest representation of the original. For Phil monochrome is ideal for images that have strong composition, and convey mood and atmosphere.

shoot

This is a photo of a captive animal taken on a workshop at a Wildlife Centre in Sussex, UK. Using a 6Mp digital SLR a 75–300mm lens was attached. Exposure was 1/125 sec at f6.7 with ISO 400 sensitivity, while white balance was left to auto. Accessing the histogram enabled a good first exposure.

> digital capture

> PhotoImpact

> levels

> greyscale

> object properties

> merge levels

> lasso tool

> invert

> gamma

> burn tool

> crop

> greyscale TIFF file

each brightness value. If for instance you have a large peak in the middle, then there are more midtone pixels (grey) than those recording highlights or shadows. General photography is best suited to having some recorded pixels across the range, but of course if you are dealing with say high- or low-key subjects you will want to make sure pixels are biased towards one end of the scale. A key 'extra' with some cameras is an overexposure warning. It is crucial to avoid overexposure with digital capture. The warning will highlight areas that are overexposed and exposure should be reduced accordingly if you need to record detail in those areas. The scale represents brightness values from 0 (black) to -255 (white).

histogram

4 object properties

5 lasso tool

1/ The original image.

2/ Levels adjustment set the basic pixel brightness.

3/ Taking the image to mono via greyscale.

4/ Object layers achieve a similar effect to layer blending in Photoshop.

5/ The lasso tool was used to make a selection.

6/ The selection area was then inverted.

6 invert selection

enhance

Less than one hour was spent on this image. Opened in PhotoImpact, it was adjusted for its tonal range with levels (2). Then colour was removed by taking it to greyscale (3). Copying the greyscale shot, it was pasted as an object (layer) over the original and object properties set for merge to soft light, and transparency to 25% (4). All object layers were merged at this stage. Next the fox's face was selected with the lasso tool (5) and inverted (6).

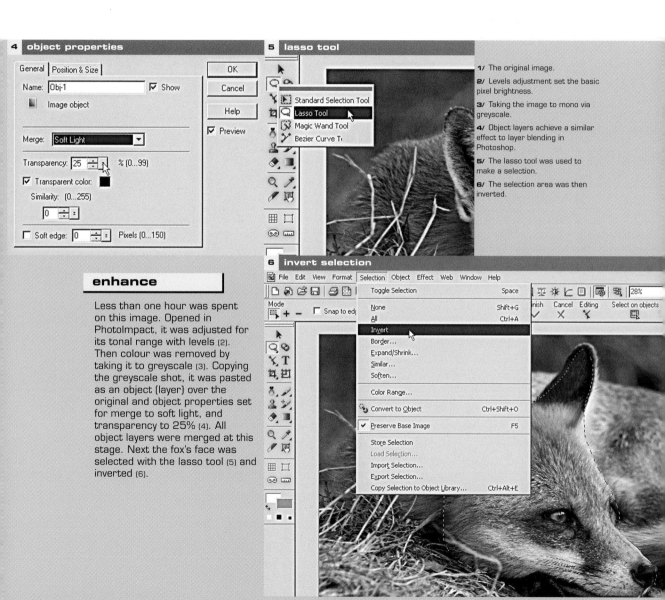

Changing the gamma (7) adjusted the midtone values of the image, darkening the active area; the two areas were then merged. A final crop (9) was preceded by using the burn tool to darken the lower left corner (8).

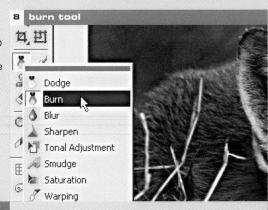

Dodge
Burn
Blur
Sharpen
Tonal Adjustment
Smudge
Saturation
Warping

7/ Brightness and contrast adjustment from selection.

8/ The burn tool adds last touches.

9/ The image was cropped for impact.

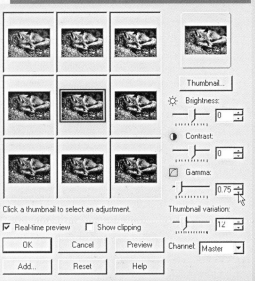

Click a thumbnail to select an adjustment.

☑ Real-time preview ☐ Show clipping

| OK | Cancel | Preview |
| Add... | Reset | Help |

Thumbnail...

☼ Brightness: ___ 0
◐ Contrast: ___ 0
▱ Gamma: ___ 0.75
Thumbnail variation: ___ 12
Channel: Master

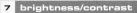

Use a crop tool as a powerful editing option, revisiting what you first composed, removing anything not adding to the impact desired.

! Many tools like dodge or burn are best used subtly providing a near subconscious effect.

Occasionally Phil prints for personal enjoyment. In this instance the shot was presented to us as a greyscale TIFF file.

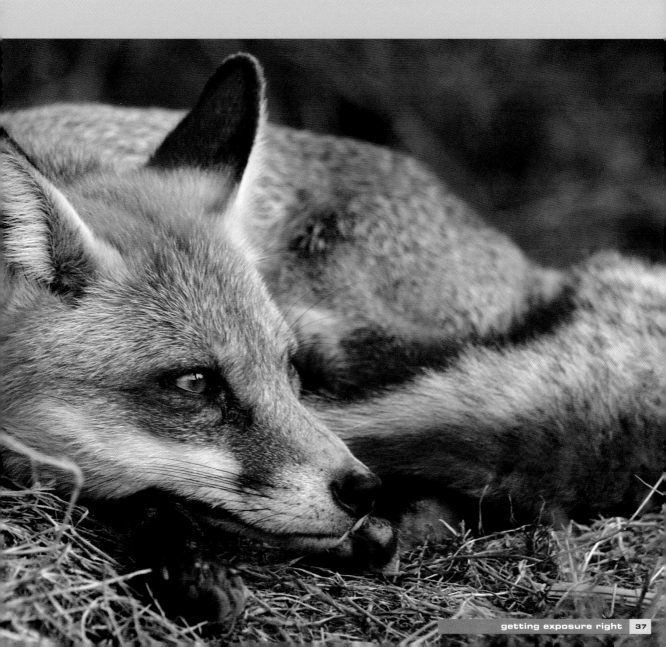

the digital negative

When light strikes a camera sensor, its brightness distribution and intensity are registered across its photosites, as are colour values usually through filtration then software assessment. The captured data once interpreted by the camera's software is in its 'RAW' form. These RAW files are best described as the 'digital negative'. Their value is immediately apparent to anyone who has worked in a traditional darkroom. They allow both an image to be reproduced in the same or alternative effects from its original state. To put it simply, it is the most flexible point from which to start post-production, and the most secure of file formats. RAW files are, however, like a native language to each camera or digital back manufacturer. This means that their own dedicated software is often the most flexible option to manipulate the data, and sometimes the only option. However, later versions of programs such as Photoshop also allow an increasing number of RAW file types to be worked upon in a complex way. These programs utilise a 'plug-in' to read the many types. The process is different to a conventional film darkroom in that the RAW file is 'processed' digitally as we apply effects that would otherwise be applied in camera automatically. The crucial point is that we choose what those effects are.

The selected camera settings for exposure, white balance, file format and others, are used when a RAW file is created in camera. However, RAW files as they are unprocessed are smaller than a TIFF file at this stage. That can make a big difference when storage size is limited, but you need a better quality image than from a JPEG with reduced writing times. Interestingly RAW files can be compressed in some cameras, shrinking the file size at capture even further, while other models only offer uncompressed capability. Importantly, they are not 'lossy' like a JPEG, even in the compressed form, so are noticeably larger than this alternative.

> digital capture
> **RAW** file
> **Photoshop**
> desaturate
> contrast
> luminance smoothing
> sepia effect
> crop
> ink jet print

2 | capture

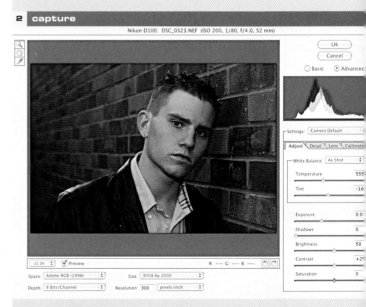

Nikon D100: DSC_0323.NEF (ISO 200, 1/80, f/4.0, 52 mm)

1/ The original image.

2/ This image called 'Chaz' by John Clements was originally captured as part of a model portfolio. He shoots using RAW data as standard unless the subject, client or end use demands otherwise. Sometime after supplying the images, John wanted to rework this one into an image that although modern, has an older 1950s' feel. For a simplified workflow, he used Photoshop to work on the RAW data.

3/ The image was converted to monochrome by desaturation.

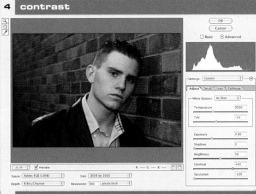

4 contrast

4/ Contrast was then increased.

5/ The 'tint' was also modified.

6/ The luminance was then smoothed.

3 desaturation

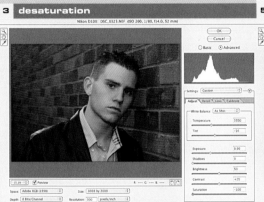

5 tint

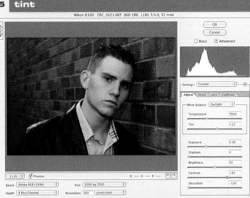

enhance

When you work on a RAW file you start from basic captured values. The 'at exposure' data remains intact as part of the file, but is not a concrete set of parameters. The shot values are contained in only part of the metadata for the file in question. You can adjust away from the set shooting criteria and create a new file. This will not be another RAW file (that cannot be changed in its basic form), but one processed into a TIFF or JPEG file format. The processing uncompresses the file if needs be, and creates data that most imaging programs can read.

6 luminance

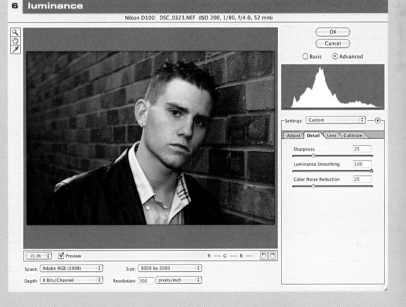

But this is just the start. The processing part is the most important. In effect we are adjusting pixel values at a most basic level by applying new algorithms. For instance, if the original image was captured with white balance set for tungsten light by mistake but the shot was actually created with flash, changing the setting in computer software from the

7 photo filter

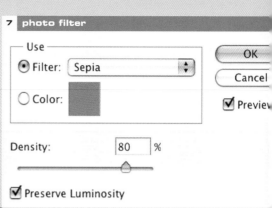

— Use
- ● Filter: Sepia
- ○ Color:

Density: 80 %

☑ Preserve Luminosity

OK
Cancel
☑ Preview

8 crop

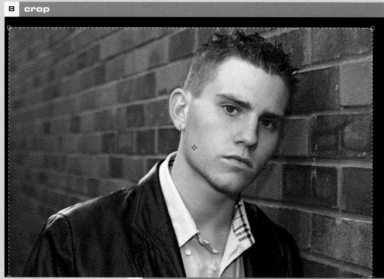

'as shot' to flash, applies a new algorithm. This adjusts the data and reprocesses it as if shot at a flash colour temperature. The image then appears more natural. To do this or make other changes with a JPEG or TIFF file is either difficult, more time consuming, or impossible. Typically white balance, exposure compensation, noise reduction and sharpening are adjusted.

9 alternative crop

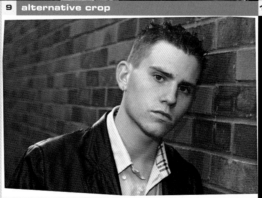

10 alternative crop

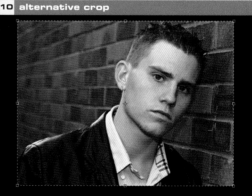

7/ A subtle sepia effect was applied using photo filter.

8/9/10/ The crop tool allowed final small touches to be made.

11/ The final image.

This post-processing aspect is akin to playing around in the 'wet darkroom'. I often find that RAW data comes into its own sometimes after the original image has been used, when other and at the time unseen needs are to be fulfilled.

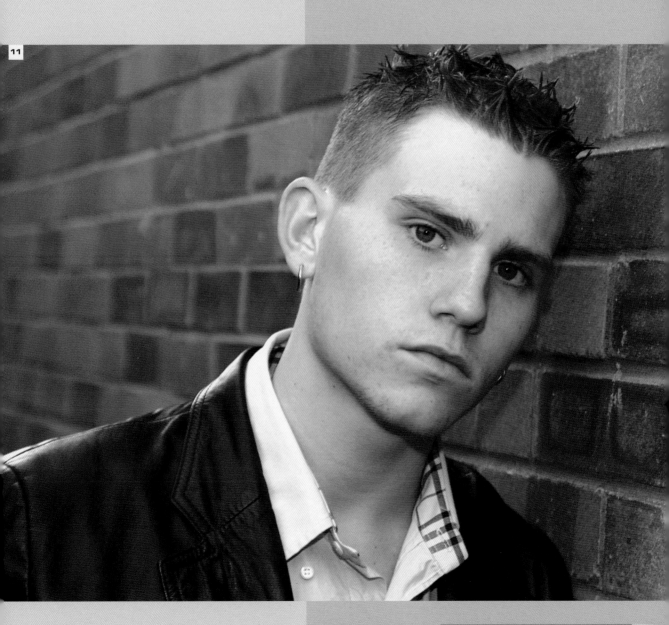

11

3 digital darkroom basics

'The Breeze' by Juergen Kollmorgen.

This image was captured digitally in Australia. A big shooter of infrared images, Juergen noticed the wind and cloud patterns, and knowing that conifers come out very well in infrared, could not resist this shot. More than two hours' work at his computer exploring different possibilities for desaturation, de-fogging and toning created the final image.

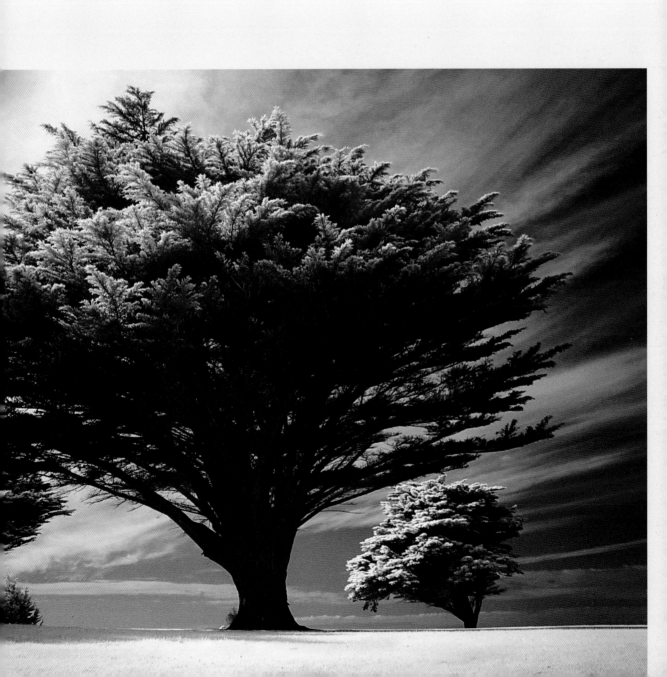

in this chapter

In this chapter we look at
important basic adjustments
including levels correction,
cloning, sharpening and cropping
for effect.

auto options

Auto levels and other 'auto'
options are a first step for
many wanting quick
adjustments. Here we look
at one example.

pages 46–47

old ideas, new approach

The dodge and burn tools
were widely used in the
'wet darkroom'. Now in the
digital age they are easier
to use than ever.

pages 48–49

basic retouching

Getting a 'clean image' is
important to all of us. That
is especially so when you
sell your work through
stock agencies. Cloning
and retouching alongside
scratch and dust removal
when scanning are
discussed here.

pages 50–51

shaping your image

Plug-in filters offer some wonderful effects not found in the native stand-alone software package. One example is used in this spread as is the useful free transform tool in Photoshop.

pages 52–53

crop, shape and size

The crop tool not only helps tidy an image, but can help create powerful new compositions with the benefit of post-capture hindsight.

pages 54–55

sharpening your image

The right amount of sharpening, either applied in camera at exposure or afterwards is vital to allow the best resolution for the intended reproduction type and size. We show one example here.

pages 56–57

tool chest

There are some common tools and filters we call upon regularly. Here we look at a selection.

pages 58–61

1

'I'm usually attracted to a subject by the way the light is hitting it. I don't care what the subject is, if the light is falling in a way that I find interesting, I'll take a shot of it.'

shoot

Getting out of his car one day with camera in hand, Stewart noticed the inside of the door reflected on his camera's viewing LCD. It had potential as an image. A quick hand-held shot at f2.8 and 1/125 sec was made using his 5Mp compact camera. This was set for programmed exposure, 100 ISO sensitivity, an sRGB colour space, and a 15mm focal length.

auto options

2

There are some simple tools and automatic options in many software programs that are often worth using at the onset as a starting point to post-capture adjustment. Stewart Whitmore's 'Grille' shows that often a relatively simple but thoughtful approach is all that it takes to create a worthwhile image.

> digital capture
> Photoshop Elements
> crop
> auto contrast
> greyscale
> RGB colour
> fill layer
> selection
> Web

Auto Levels This is a very popular adjustment, used early in the post-production process. It can be set either by following Image > Adjustment > Auto Levels in Photoshop, or selecting Levels then the auto option. It automatically adjusts the black point and the white point in an image so those that start out as the brightest are reproduced as pure white (255) and the darkest as 0 brightness levels, regardless of what brightness they started out as. Those in between are redistributed proportionately. The image therefore increases in contrast, particularly noticeable with 'flat' images, but also as subtle changes in images with naturally higher contrast. The down side is that each colour channel that makes up the image is adjusted individually. This can change the colour of the overall image to varying amounts so may not be ideal all of the time. Auto levels works best with images with a good mix of brightness values.

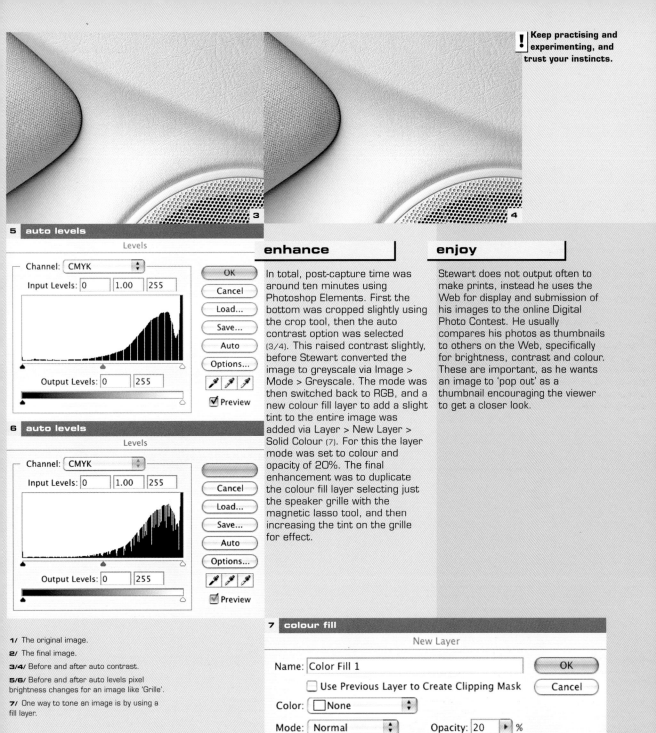

! Keep practising and experimenting, and trust your instincts.

3

4

5 auto levels

Levels

Channel: CMYK

Input Levels: 0 | 1.00 | 255

OK
Cancel
Load...
Save...
Auto
Options...

Output Levels: 0 | 255

☑ Preview

6 auto levels

Levels

Channel: CMYK

Input Levels: 0 | 1.00 | 255

Cancel
Load...
Save...
Auto
Options...

Output Levels: 0 | 255

☑ Preview

enhance

In total, post-capture time was around ten minutes using Photoshop Elements. First the bottom was cropped slightly using the crop tool, then the auto contrast option was selected (3/4). This raised contrast slightly, before Stewart converted the image to greyscale via Image > Mode > Greyscale. The mode was then switched back to RGB, and a new colour fill layer to add a slight tint to the entire image was added via Layer > New Layer > Solid Colour (7). For this the layer mode was set to colour and opacity of 20%. The final enhancement was to duplicate the colour fill layer selecting just the speaker grille with the magnetic lasso tool, and then increasing the tint on the grille for effect.

enjoy

Stewart does not output often to make prints, instead he uses the Web for display and submission of his images to the online Digital Photo Contest. He usually compares his photos as thumbnails to others on the Web, specifically for brightness, contrast and colour. These are important, as he wants an image to 'pop out' as a thumbnail encouraging the viewer to get a closer look.

1/ The original image.

2/ The final image.

3/4/ Before and after auto contrast.

5/6/ Before and after auto levels pixel brightness changes for an image like 'Grille'.

7/ One way to tone an image is by using a fill layer.

7 colour fill

New Layer

Name: Color Fill 1

OK
Cancel

☐ Use Previous Layer to Create Clipping Mask

Color: ☐ None

Mode: Normal | Opacity: 20 ▶ %

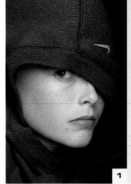

1

'Digital may see the renaissance of black and white because of the ease with which a monochrome image can be extracted from a colour original using "digital filters" instead of conventional glass filters over the lens.'

3 **dodge tool**

■ 🔍 Dodge Tool

🖐 Burn Tool

⬤ Sponge Tool

old ideas, new approach

Louis McCullagh is a professional photographer based in Belfast, Northern Ireland. He likes natural-looking imagery, and his digital photography is geared towards that from capture onwards. This includes the use of the digital equivalent techniques of 'dodge' and 'burn', stalwart techniques of a traditional chemical darkroom.

shoot

'Looking' was taken on a 6Mp digital SLR fitted with a 70–200mm f4 professional series lens. Louis believes that monochrome places greater demand on composition and exposure than colour photography, but when used successfully can give a very strong image. This shot was lit by two studio flash heads in the photographer's studio, one with a softbox attached (beside the camera and above head height), the other with an umbrella fitted. (This was placed lower and to the right of the camera at 45 degrees.) A reflector was also placed under the subject's face. The resulting exposure was f/13 at 1/200th sec, with 100 ISO sensitivity selected. As the camera's sensor was smaller than a full frame model, the 165mm focal length selected helped 'flatten' the background. The hood was adjusted for effect over one eye, which was important when it came to post-production and the final shape of the image.

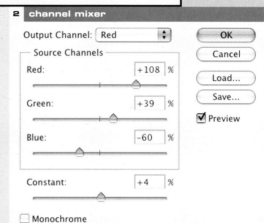

2 **channel mixer**

Output Channel: Red

Source Channels

Red: +108 %

Green: +39 %

Blue: -60 %

Constant: +4 %

☐ Monochrome

OK
Cancel
Load...
Save...
☑ Preview

1/ The original image.

2/ Channel mixer showing the settings used for the mono conversion.

3/ The dodge tool was used to lighten a few areas on the face.

4/ The final image.

enhance

Taking the image into Photoshop, its RAW file conversion option was used, bypassing the manufacturer's dedicated software. The image was cropped to obtain the square format which worked well with the diagonals created by the hood. The 'swoosh' logo was deleted using the patch tool, with care taken to line up the texture in the cloth. Next came conversion to monochrome using the channel mixer. This was also set to remove the freckles but retain tone in all the skin. Settings for mono conversion were red (+108), green (+39) and blue (-60). Constant was placed at +4 (2). The red was then set to 100% and then blue was used to remove the freckles and the

green to put a smooth tone back in the skin.

The dodge tool (3) lightened a few areas on the face, plus a small shadow on the lip. To fade any remaining freckles, the clone tool was used to 'lighten at 20%'. A plug-in, PK Sharpener, was used to brush on sharpening over the eyeball and a smaller amount the nostril and lips. The material was held back when sharpening overall, as portraits like this can show dramatic changes with sharpening in this area. The edges and corners were burnt in a small amount around with the burn tool. In total, around 30 minutes were spent working on this image.

> digital capture
> JPEG file
> Photoshop
> RAW plug-in
> crop
> patch tool
> channel mixer
> dodge tool
> clone tool
> PK Sharpener
> burn tool
> Web
> RGB TIFF file

'Get the exposure correct and avoid having to correct mistakes in Photoshop.'

enjoy

Louis' prints are commissioned by clients, plus he outputs personal work for pleasure. He likes monochrome, as it can be very forgiving in portraits, especially for those with any reddish blotches or spots on Caucasian skin. Louis aims to create an image that looks untouched and as natural as possible, by avoiding very unnatural effects such as over sharpening or making the whites of the eyes too bright. This image was supplied as an 8-bit RGB TIFF file for this book, but was first found as a low-resolution JPEG on the Web.

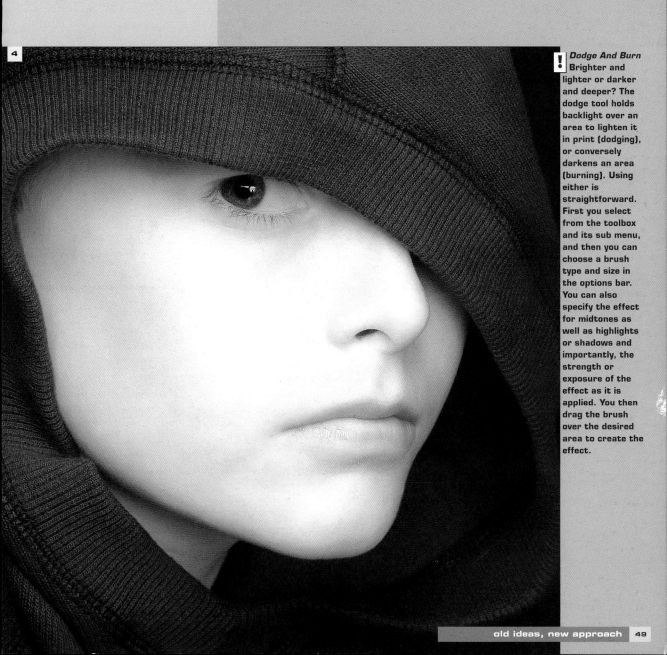

4

! *Dodge And Burn* **Brighter and lighter or darker and deeper? The dodge tool holds backlight over an area to lighten it in print (dodging), or conversely darkens an area (burning). Using either is straightforward. First you select from the toolbox and its sub menu, and then you can choose a brush type and size in the options bar. You can also specify the effect for midtones as well as highlights or shadows and importantly, the strength or exposure of the effect as it is applied. You then drag the brush over the desired area to create the effect.**

'My image post-processing over the past few years has been increasingly dominated by the need from the best online image libraries for 100% perfection at pixel level.'

shoot

This particular shot was taken in Beiling Park, the little-known old Manchu Dynasty Imperial Palace in Shenyang, North East China. This area is close to Siberia and gets extremely cold and is therefore off the typical tourist routes.

The shot is titled 'Photography in the Snows: Beiling Park, Shenyang, China', and was captured on very fine-grain 100 ISO colour slide film. This was chosen for its colour neutrality. As for hardware, he used a manual focus 35mm SLR, fitted

with a 65–200mm telephoto zoom. There was a lot of light and glare from the snow, so Jon bracketed exposures. The best result was exposed at +1.5 stops.

basic retouching

Jon Bower is a freelance professional photographer. Extensive travels around the globe have provided his source images and he supplies material to an impressive list of stock clients. What does he like about digital black and white? 'The immediacy, and the way it forces one to focus on essence, form, contrast, texture and lighting.' But no matter the choice of colour or monochrome, some things remain fundamental steps to good imagery.

> 35mm slide film capture
> exposure compensation
> 4000dpi scan
> TIFF file
> Photoshop
> clone tool
> layer
> curves
> hue/saturation
> stock

enhance

Jon finds this particular film scans well, an important point in the digital workflow. The scan was made at 4000dpi using a dedicated 35mm film scanner. Apart from calibrating the scanner, Jon does not adjust images during the scanning process. He prefers to do this later in Photoshop. In this case, the straight scan was de-spotted then converted to mono via the channel mixer. A final, but slight adjustment using curves and levels was made to change contrast and tonal range. As for de-spotting, the small things like this make a big difference. Any photographer will need to utilise either basic or advanced retouching to 'clean up' an image. Dust when film scanning or recorded on a digital camera's sensor is a fact of life for most of us. Jon has to maximise his retouching effect, as his stock clients simply demand perfect images.

Jon starts after the basic scan by viewing the whole image to see if it is worth going any further. If things look promising, he then

zooms right in on the image in Photoshop to view the pixels. Any scanner glitches or defects like dust marks are then removed. Then he looks at removing any distracting aspects. A variety of tools are used for this. Cloning brushes of different sizes and opacities are fundamental, while the healing or patch tools are more useful when trying to keep tonality and lighting effects in tune with the original look. Jon works both on the whole image and a masked area when that is beneficial. Duplicate layers are used before finally adjusting the whole image for general effect with controls like curves and hue/saturation. A final review assesses the full image once more before archiving and distribution.

1 dust and scratch

▼ Digital ICE4 Advanced

☑ Enable Digital ICE Normal

☑ Enable Post Processing

Digital ROC 0

Digital GEM 0

☐ Enable Digital DEE

Shadow Adjustment

 50

More>> Redraw

Scratch and Dust Removal
If your scanner software allows, automatic dust and scratch removal can dramatically reduce the amount of work needed for retouching post-capture. It works by detecting anything not at emulsion level such as dust lying on top and ignores it during the scan. It then replaces it with data from nearby. However, the parameters set need careful consideration to make this most effective. The scanning time increases and a slight softening of the image compared to a normal scan can take place, so may need to be counteracted post-scan through aspects such as USM and curves adjustment for example. There is a weakness of this time-saving option with conventional monochrome films. Unless these are colour technology-based (C-41 process), the effect can be far from effective.

2 clone tool

Brush: 9 Mode: Darken Opacity: 79% Flow: 83%

1/ Dust and scratch removal software can be very beneficial, but not every film is compatible.

2/ Cloning tool options.

3/ The final image after retouching.

! To quickly set 100% magnification in Photoshop, double click the zoom tool icon.

! *Cloning Tool* Some people refer to this as the rubber or cloning stamp. It is one of the most useful tools at our disposal. Select specific pixels as your reference by clicking on to those you intend to copy while holding the alt key down. You can then reproduce them elsewhere in the image by clicking the mouse over a new area. Movement covers a larger area, but a single click over a point, such as when removing small blemishes in a portrait is equally useful. Cloning can be made on different layers or on to other images. Settings are best selected with thought to meet your specific need. Brush size is the most obvious, but opacity, flow and blend mode options provide a vast range of possibilities and control. Simple cloning is easy to master, but it is the application of the full variety of effects after experimentation that makes it an art in itself. Another major consideration is working with aligned or non-aligned areas. The first will allow you to stop then continue from where you left off. Non-aligned will start again each time you re-select the cloning location.

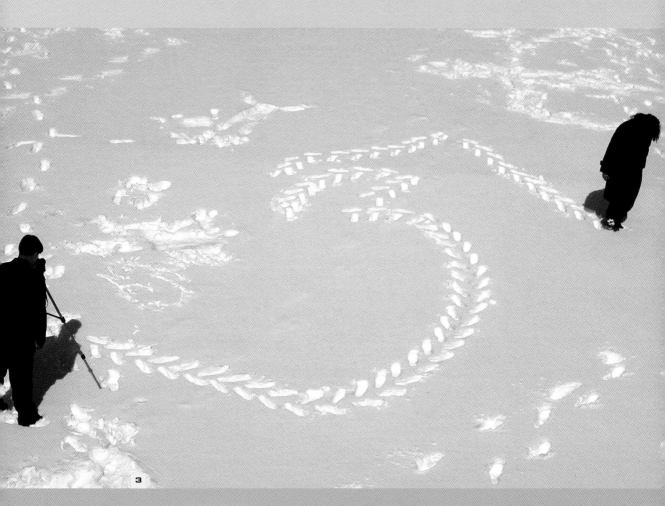

3

enjoy

Jon sometimes prints his work for his own satisfaction and display needs. However, his business sells through picture libraries such as Alamy, Telling Images and Ecoscene. Many images are also sold direct to magazines or for book publications. As a guide, Jon generally avoids supplying images that have been obviously manipulated, but 'if it improves on the original, then so be it...'

'Monochrome can communicate better than colour in some images. With digital manipulation the effect can be even better.'

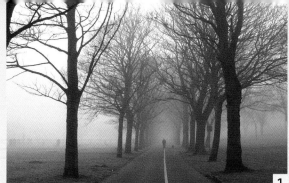

1/ The original image.
2/ Size was adjusted via free transform.
3/ The layer blend option is very flexible for fine tuning effects.
4/ The final image.

shaping your image

Digital artist Miguel Lasa has the optimistic attitude of all good outdoor photographers, passionate enough about their art. They go out in less than comfortable situations to nail a significant shot. The rewards will occasionally be images that have a serene feel with few other people around, already well on the way to being 'moody' shots before post-production.

shoot

Although Miguel uses a 6Mp digital SLR for most of his photography, a digital compact was used for this shot. The exposure was made at 1/250th sec at f/4.5. 'Walking' was taken in Hartlepool Park, near where he lives. This particular misty morning instigated a rush to the park to capture the image; as a result he was ten minutes' late for work that morning.

enhance

Miguel likes to give his images an artistic mood to communicate with the viewer. This can take up to two hours during post-production, using Photoshop and a host of plug-in filters. In the case of 'Walking' he used a plug-in called Dreamy Photo by AutoFx. First it was applied to the original image after a small amount of cropping and using free transform via Select > Select All > Free Transform to adjust size (2).

Within the menu options of Dreamy Photo, Miguel set the active colour to white to get the mood required. The filter produces a top layer of effect that was blended with the original using screen mode at opacity of 42 (3). After applying the filter, the image was desaturated in Photoshop via Image > Adjustments > Desaturate and the filter applied for a second time using a separate layer. This time it was blended in normal mode at an opacity of 31.

2 free transform

X: 3315.5 px | Y: 1839.4 px | W: 90.5% | H: 112.4% | △ 5.0 ° | H: 0.0 ° | V: 0.0 °

3 layer blend

Layers | Channels | Paths

Screen | Opacity: 42%

Lock: | Fill: 100%

Layer 0 copy

Layer 0

> digital capture
> JPEG file
> Photoshop
> Dreamy Photo plug-in
> free transform
> Dreamy Photo plug-in
> layer blend
> desaturate
> layer blend

Free Transform gives lots of control when it comes to adjusting the shape of an image. It transforms an image or selection to re-scale as in 'Walking'. It can skew, rotate or change perspective of an image. It works without having to make more time-consuming adjustments through other means. Various key commands change the type of adjustment, while settings can also be typed in such as a degree of rotation. A useful re-scaling can be achieved by holding the shift key down while adjusting a drag handle. This re-scales the shot and keeps it in proportion to the starting dimensions. But you must select the area you wish to change first.

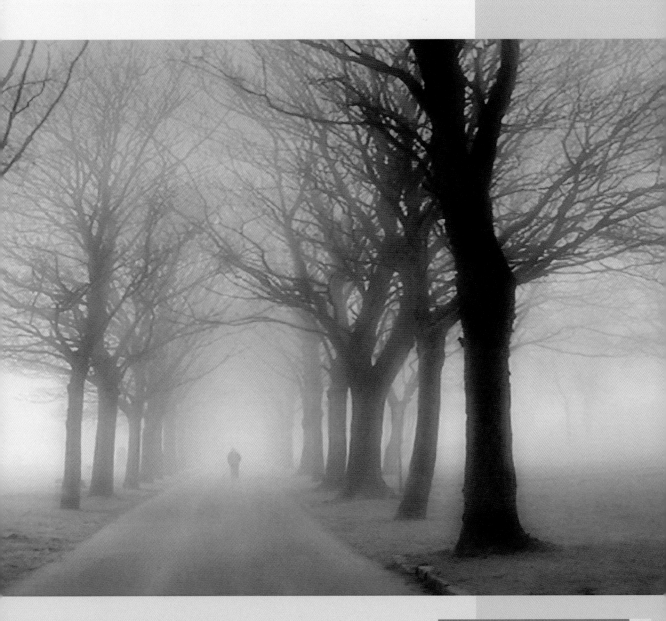

! | If you know the output size you want, fill in the width and height dimensions to retain the ratio as the image is cropped.

! | It is useful when cropping an image to maintain your preconceived output crop size. For instance, setting width and height for 9 x 6 inches will control the crop to an area that will print at that size once the change has been made.

crop, shape and size

You have your image but is it fundamentally right? Could the shape be better? Are all the straight lines totally straight? These are some of the basics to consider before moving on. The crop tool is often called for. Clicking and dragging will create an easy-to-control cropped area, within an image (1/2). Gripping boxes can be pulled afterwards to adjust it. The masked off area outside the crop can also have its opacity adjusted. Another useful aspect is the perspective crop. If this box is checked you can correct a subject that should be near rectangular or square, but has been recorded with straight-line distortion or what is called 'keystoning'.

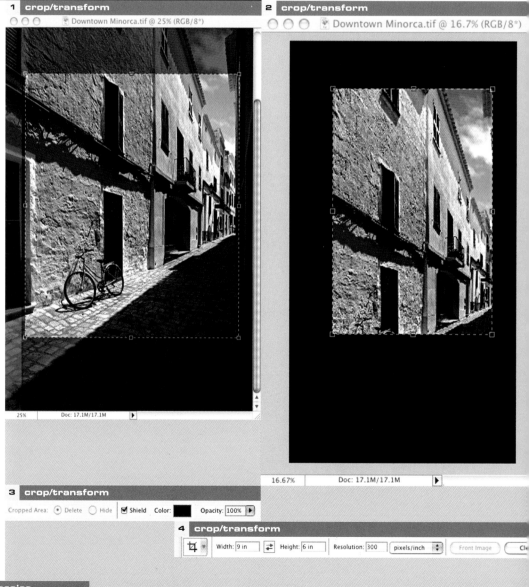

1 crop/transform
Downtown Minorca.tif @ 25% (RGB/8*)
25% Doc: 17.1M/17.1M

2 crop/transform
Downtown Minorca.tif @ 16.7% (RGB/8*)
16.67% Doc: 17.1M/17.1M

3 crop/transform
Cropped Area: ⦿ Delete ◯ Hide ☑ Shield Color: Opacity: 100% ▶

4 crop/transform
Width: 9 in Height: 6 in Resolution: 300 pixels/inch Front Image Cl

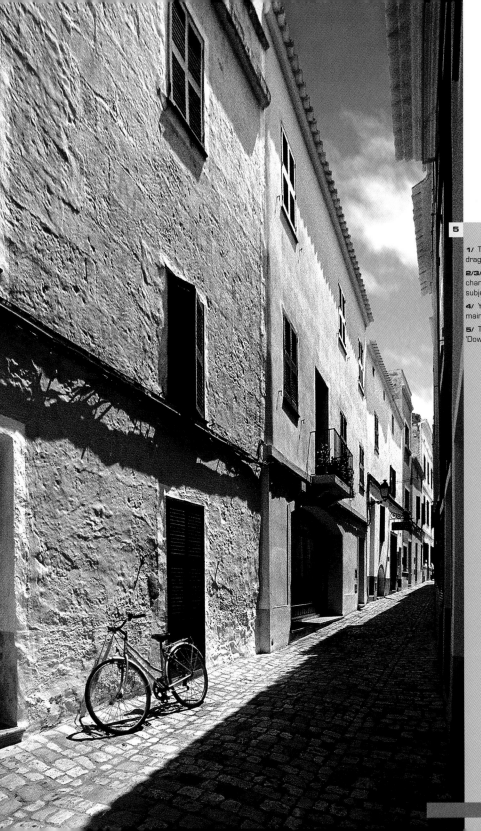

1/ The basic crop provides grip boxes to drag on to change your initial selection.

2/3/ The opacity of the masked area can be changed for viewing ease depending on the subject's tones.

4/ You can key in dimensions for your crop to maintain a desired ratio if beneficial.

5/ Tony Perryman created this image called 'Downtown Minorca'.

'I have always liked monochrome images. Colour can often be confusing; after all it is a whole extra dimension to worry about. Monochrome images are often more powerful at capturing the scene and feeling at the time of the shot.'

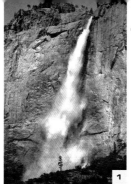

1

'The Yosemite Fall drops 1,430 feet in one sheer fall, the highest free leaping waterfall in the world. Many pictures have been taken of it and it is often difficult to capture an original viewpoint. I wanted to somehow give a sense of

scale to the picture. I moved away from the popular places and found a vantage point that allowed me to include the giant redwood in silhouette. This tree is one of the tallest in the world and gives real impact to the picture.'

sharpening your image

Nigel Danson is based in Manchester in the UK, but his 'Giant Redwood at Yosemite Falls' was taken in the US, at one of the most famous locations for monochrome landscape photographers, synonymous with Ansel Adams. Yosemite National Park remains an inspiration for today's digital monochrome photographers as much as the masters of the past, but you do wonder what they might have done with the tools now at our disposal.

> 35mm monochrome film

> scan

> TIFF file

> Photoshop

> crop tool

> clone tool

> lasso tool

> curves

> levels

> USM

> ink jet print

shoot

An enthusiast, Nigel nevertheless used a professional 35mm film camera for this image, loaded with a 125 ISO film of medium speed and contrast. Today, most of his imagery is shot on a 6Mp digital SLR and both come from the same manufacturer's system and utilise the same lens mount. This gives plenty of flexibility when it comes to maximising the angle of view of a lens as the digital camera has a smaller than full frame sensor. A 100–300mm f4 lens was used to take this photograph.

enhance

Nigel spent about two hours post-capture on this image. The film was scanned at 2820dpi, giving a file size around 31Mb. He usually scans in colour as it seems to give him better results. Taking the image into Photoshop he cropped it and de-spotted, an invaluable thing for every image and especially in digital photography. Selecting the water with the lasso

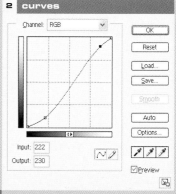

2 curves

3 levels

4 layers

tool (with a feature of 50), Nigel was able to adjust the tone curve of the water (2) to increase the contrast at the white end of the scale, while the rocks needed a levels adjustment. If only a global levels adjustment was made, the water would have burnt out. After correcting the water using a new adjustment layer, it was re-selected and inverted via Image > Adjustments > Invert and a new fill layer used to adjust for the rest of the image including the rocks. The image was then sharpened with the unsharp mask set for amount 82%, radius 1.2, and threshold 2 to create a print ready image (5).

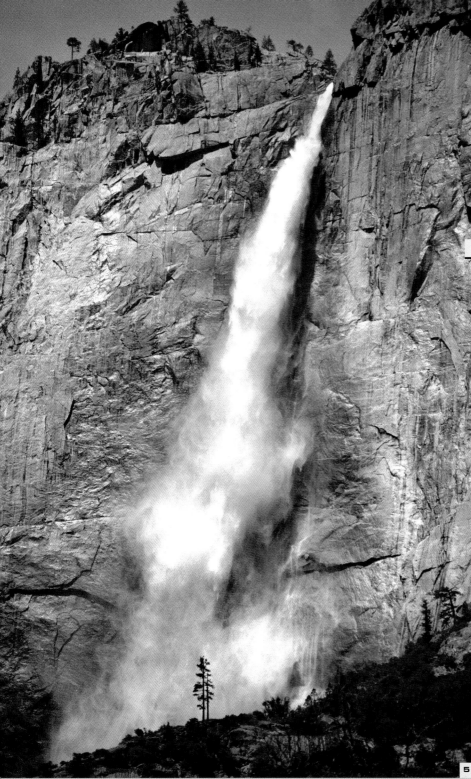

1/ The original scanned image.

2/ Curves are corrected.

3/ Levels adjustment is made on the rocks.

4/ Layers enable precise control of effect.

5/ The final image once the unsharp mask has been used.

enjoy

Nigel mostly makes prints for his own enjoyment, but he has also had a few exhibitions and has subsequently been able to sell prints from them. He outputs his images on to matt paper using an A3 ink jet printer utilising pigment rather than dye inks for better longevity. This accepts its own special black-and-grey cartridges to simulate a continuous tone image. These are then dry mounted on card, and with a white card (snow white) mount on top. He uses simple frames of either black or silver.

5

> 'You can never be sure of what will sell; often we are just too close emotionally to our images so our impression of them is distorted. Others have a clearer view.'

tool chest

The range of the tools we use today as photographers is mind blowing when you consider the capture side then post-production and output. Nevertheless, mastering these to a sufficient level is a must if we are to be productive in output quantity and quality. Here we look at some of the more common aspects used in the digital darkroom and give some pointers.

shoot

This image was captured on a dull January day. It was as a result flat, even though the original had a splash of red to give impact. Sadly John Clements could not get close enough to capture reflections in the instruments of the surroundings, which would have been nice, as would a touch of glint here and there but not without brighter light. He used a 3Mp digital SLR and a zoom lens.

enhance

John still wanted to do something with this shot, but filed it away for a few years. Playing around one day he decided to try and go for something surreal but also to add a feeling of movement. Taking the image to monochrome in Photoshop via Image > Adjustments > Hue/Saturation (-100), he then applied the wave filter via Filter > Wave. It wasn't exactly what he had in mind, but it does create more of an interest than the straight shot.

your interface

Arguably as important as any camera and lens is the monitor. Technology has come a long way and is improving all the time. A CRT (cathode ray tube) screen is still technically the best generally when it comes to images, although many people use an LCD. A flat CRT of at least 19 inches diagonal screen measurement is best, but most pro photographers and DTP people gravitate to larger, so 21 inch or bigger is the norm. Calibrate your screen regularly; don't be tempted not to. It will affect the tones you see in mono images. It is also a good idea to let the screen 'warm up' for around 30 minutes before working on a calibrated monitor for critical analysis. Degauss regularly also. LCD screens do not show the same colour and tonal range and can be more difficult to calibrate in some instances. If you can get your screen looking right, this is a major part of top-level image-making.

1/ The original digital capture.

2/ The final image.

3/ Wave filter effects.

4/ Levels are a good way to view pixel brightness and adjust an image globally.

> digital capture
> JPEG
> Photoshop
> desaturate
> wave filter
> dye sub print

3 levels

Number of Generators: 5

Type:
● Sine
○ Triangle
○ Square

OK
Cancel

	Min.	Max.
Wavelength:	50	496

	Min.	Max.
Amplitude:	5	35

	Horiz.	Vert.
Scale:	100 %	100 %

Randomize

Undefined Areas:
○ Wrap Around
● Repeat Edge Pixels

white and black points

The most fundamental corrections for images captured in colour with a digital camera, including poor light conditions, are the white and black point settings. Using the white eye dropper shown in the levels dialog box in Photoshop or similar, a position in the image that should be white is clicked upon. This forces the selected pixels to become so, and may correct a colour cast. Further points can be selected if need be. Likewise, a true black can be chosen with the black eye dropper.

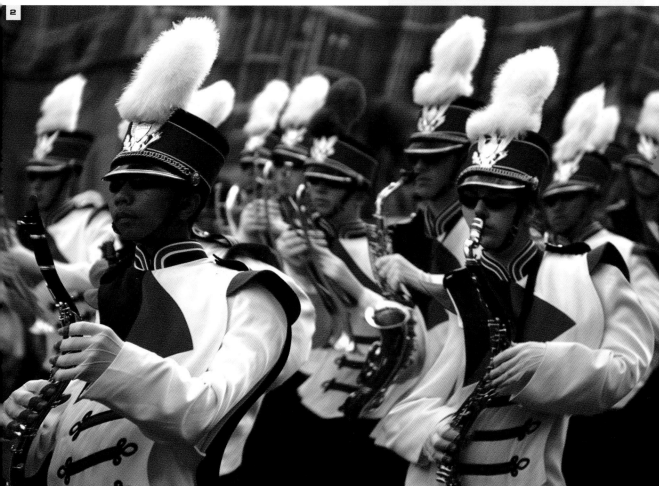

2

Filters either on camera or within software can be used. Applying over a lens, experiment to see the effects once you have converted to monochrome as this will not always give similar results as when shooting film. Here one of the numerous filter effects with software was applied. Such options are fundamental to many people's work.

threshold, amount and radius

Many options have these aspects to select for best use of the effect. Threshold specifies the point at which the desired action takes place. In unsharp mask (USM) for instance, it is the contrast point at which the effect starts. Amount is the quantity applied, while radius determines how wide the effect will be in pixel terms. USM needs to be applied with care. High-resolution images may typically need between 150 and 200%, but other uses only require much smaller amounts. Too much and 'aliasing' or 'jaggies' appear.

5 unsharp mask

OK

Cancel

☑ Preview

100%

Amount: 50 %

Radius: 1.0 pixels

Threshold: 3 levels

6

! It is best when judging images critically to select a mid grey as your screen background colour. This will not adversely affect your perception of the image in the way a multicoloured background will.

9

control

This digital infrared image was shot by Anton Falcon in the mountains overlooking the San Luis Obispo valley. It changes from beginning to end dramatically, but only because Anton has mastered the tools to get him to where he wants to go.

7

8

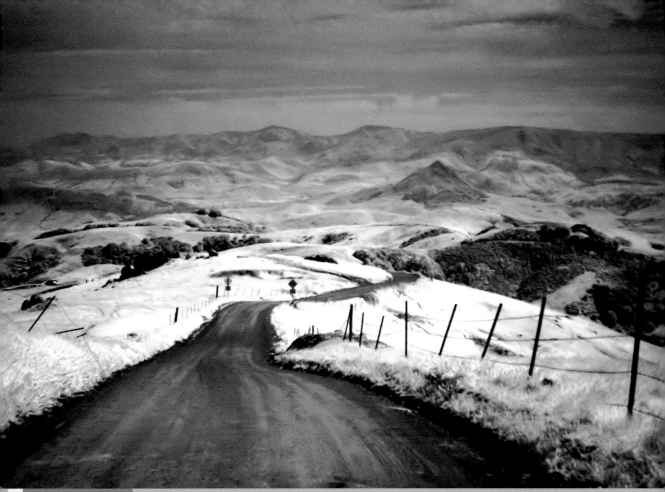

5/ The unsharp mask is the basic sharpening approach.

6/ The original exposure.

7/8/ Stages of development post-production.

9/ The final image.

10/ Auto levels, contrast and colour are useful to apply when in a hurry.

! Amongst the many adjustable options, auto levels, contrast and colour are useful to apply when in a hurry. Often doing a good job, they nevertheless can make things look worse than when you started so do not rely on them as a quick fix.

! Apply USM or other sharpening at the end of the process. As a guide for capture, the larger the image will be reproduced at, the lower the amount of in-camera sharpening that should be applied. Many set a digital camera to zero (none) with this in mind.

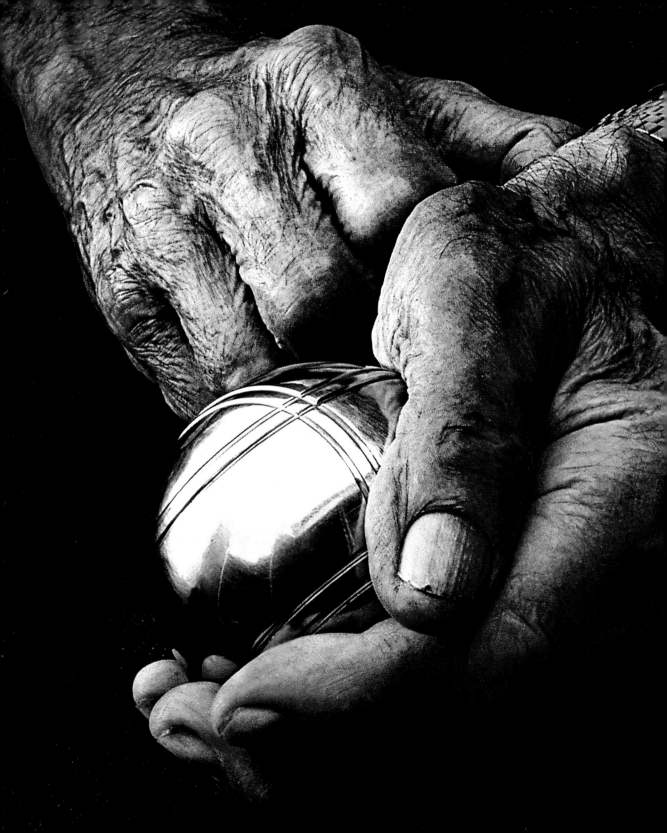

4 intermediate stages

'Waiting To Play' by Tony Perryman.

This shot was digitally captured on a 5Mp SLR. Exposure was made at f/8 using 80 ISO and a 19mm focal length. In Photoshop hue was adjusted to create a subtle yellow sepia tone. An adjustment layer with levels adjustment darkened the image, and then using a small soft-edged brush, Tony cut through the adjustment layer exposing the boule and the thumbnail. The dodge and the burn tools lightened and darkened the arms and watch. Sharpening followed, then using the eraser tool set at 40% the edges of the arms and hands were erased to soften them slightly. Flattening the layers and increasing the canvas size before adding a black outer border finished the image.

in this chapter

This chapter moves beyond the basics to some other useful or common ideas.

noise reduction

Noise in an image can be a double-edged sword. Generally we want to reduce it as much as possible and this spread shows how one photographer tackled the task.

pages 66–67

using layers

Many photographers find using layers critical to their post-production. This spread majors around this issue.

pages 68–71

lab colour

One of the under utilised aspects of advanced manipulation software, lab colour mode can be especially useful to the monochrome worker.

pages 72–73

high key

A popular type of image in monochrome, here we look at an eye-catching 'high key' shot in the digital age.

pages 74–75

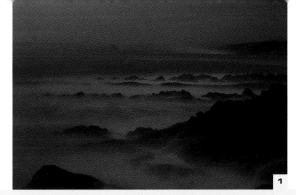

noise reduction

No matter how good the image, it can be ruined if noise or other artifacts are too prominent. So how do you correct this? Professional photographer Anton Falcon is based in San Francisco, California, USA. He likes to use a plug-in to automatically reduce noise. This is particularly important to him as he specialises in infrared capture, often based on long exposure times that can increase the presence of noise.

shoot

This shot is called 'Washed Away' and was taken on a 6Mp digital SLR using a 24–70mm f/2.8 lens. The location was Montana De Oro State Park, in Los Osos, California. This is Anton Falcon's favourite state park, only about 12 miles away from his college town. He returns there occasionally to photograph what is arguably one of the most beautiful parts of California's Central Coast. Exposure was made at f/9.5 for 30 seconds using programmed exposure.

enhance

Anton did not take long working on this image post-capture. He used Neat Image, a plug-in for Photoshop, to clean up the noise caused by the long exposure. The results were impressive.

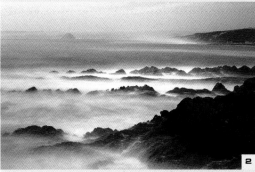

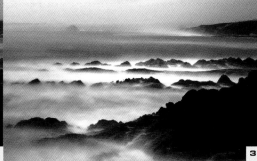

1/ The original image.

2/3/ The intermediate stage changes to 'Washed Away'.

4/5/ Before and after using the median filter.

6/ The final image, 'Washed Away'.

> digital capture
> JPEG

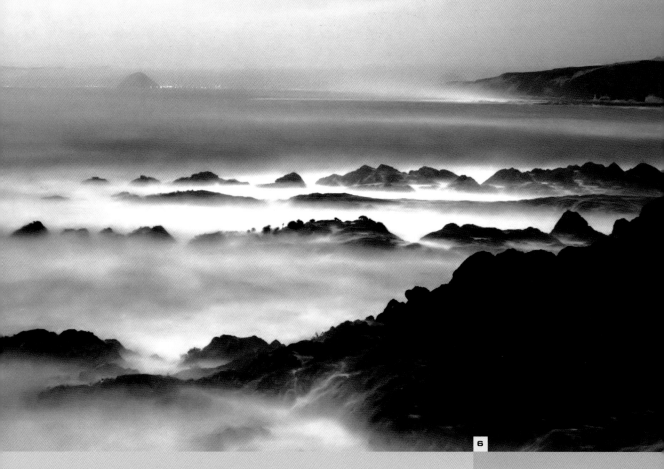

6

blurs a selected area except those borders where significant colour changes occur. This keeps detail and reduces the look of noise. The median filter blends pixel brightness within a selected area by discarding those markedly different to their neighbours, replacing with one similar to those left. It is usually best to apply this at small radius amounts. On a similar vein a small gaussian blur applied over an area can help mask the prominence of noise.

He makes prints for both his own enjoyment and exhibition. He also successfully sells his prints online.

4 **median**

OK
Cancel
☑ Preview

─ 100% ⊞

Radius: 1 pixels

5 **median**

OK
Cancel
☑ Preview

─ 100% ⊞

Radius: 4 pixels

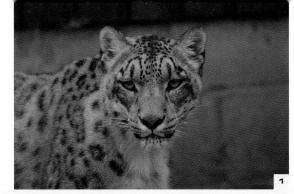

1

using layers

There are so many fundamental commands and techniques to master if you want to gain the most from your post-production. Many people would rightly state that the use of layers or similar in other programs is one of, if not the most useful.

shoot

The original photograph was taken of a captive animal at Santago Rare Leopard project, Hertfordshire, UK. This is a privately owned collection of endangered species that contributes to international conservation/breeding programmes. Phil Preston, a keen amateur, used a 6Mp digital SLR with a 75–300mm zoom lens attached. Monochrome makes him think more about image tonality, in terms of what is needed to create a good image.

! Layers are a feature it pays to master. The principle is simple enough. By placing components of an image separately one on top of another, they can be moved around in terms of location, both as a stage in an image stack, and part of the image area they cover. Further refinement is that adjustments can be made to each layer. For instance, to tone, scale, opacity and many other aspects. That greatly enhances the amount

enhance

Phil uses PhotoImpact 8 as his editing software having used previous versions and been very happy with them. 'Objects' in PhotoImpact are the equivalent of 'layers' in Photoshop. The image was cropped and had a levels adjustment made (2). A copy was made and had its colour removed by reducing the saturation (3).

> digital capture

> JPEG

> PhotoImpact

> crop

> levels

> copy

> desaturate

> objects

> eraser tool

> saturate

> burn tool

> USM

> RGB TIFF file

2 levels

Before | After | Dual View | (1369, 1835) R:107 G:101 B:87

Channel: Master ▾ ☑ Preview

Reset

Stretch

Equalize

Option...

255

Output levels:

0

Input Level: 2 | 1 | 210

OK | Cancel | Help

of information that can be manipulated for its optimum look. The order of layers can be changed whenever needed. Once happy, you 'merge' or 'flatten' the layers. The first will keep their individual characteristics so these can be used again in a suitable program, but the file size can get large. The second compresses the data into the final image and the individual layers cannot be reopened.

! *Background Layer* The background layer [4] is a blank canvas or starting image on to which other component layers are placed. In Photoshop go to File > New. Set parameters such as size, resolution and colour mode. This can become an ordinary layer by renaming it after double clicking its position in the layer palette.

! *Layer Palette* This controls layers in the order you choose. Clicking on a layer [5] makes it active. Layers can be visible or invisible by clicking on the eye symbol for each one. This can simplify the interface when working on complex images. Make a layer active then drag it to the waste bin icon to remove it. Change positions by dragging the chosen layer to where you want it in the stack. You can link different layers, so their component parts can be moved together into a new part of the overall composition.

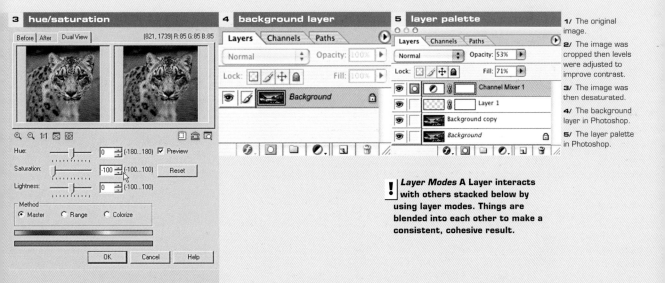

1/ The original image.

2/ The image was cropped then levels were adjusted to improve contrast.

3/ The image was then desaturated.

4/ The background layer in Photoshop.

5/ The layer palette in Photoshop.

! *Layer Modes* A Layer interacts with others stacked below by using layer modes. Things are blended into each other to make a consistent, cohesive result.

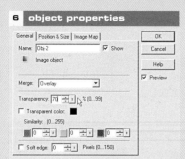

6/ Merged objects (PhotoImpact's layers).

7/ The eraser tool reintroduces some colour for impact.

8/ Saturation was then increased.

9/ The final image after the burn tool and USM had been applied.

Setting merge mode and transparency (6), the monochrome image was merged and then copied and pasted on to the original using objects. The eraser tool was then utilised to reveal eye and nose colour below (7). Saturation was then increased (8). Final touches were added by using the burn tool and then USM.

7 **eraser tool**

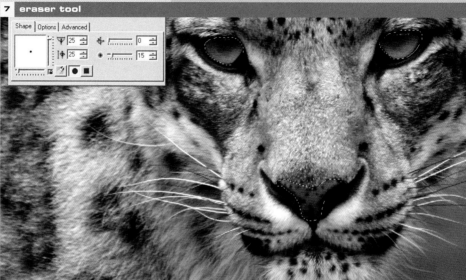

8 **hue/saturation**

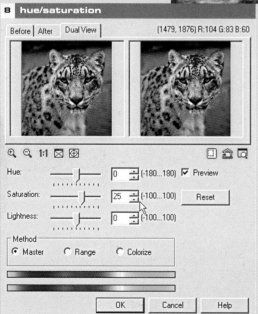

enjoy

Occasionally Phil makes prints for personal enjoyment, but his work has been published in numerous books and magazines. The final image here was supplied as an RGB TIFF file.

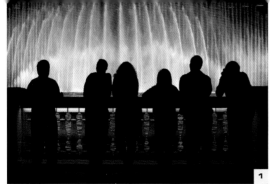

'I shoot many types of subjects and situations. For instance: action photography, images with a graphic feel, candid portraits. I feel it makes me a better all-round photographer.'

'I am most drawn to images with strong lines and graphic appeal. Many of these lend themselves well to conversion to monochrome as the lines and shapes are the most important feature of the image.'

lab colour

Many photographers have yet to realise the potential of lab colour mode. It can be a very useful tool. Professional photographer Heather McFarland is based in Gaylord, Michigan, USA, and used lab colour as part of the production cycle for 'Water Watchers'. It can be a flexible friend to the monochrome photographer.

shoot

A professional digital SLR was used hand-held for this shot captured at 500 ISO sensitivity. This allowed an exposure of 1/45th sec at f3.3, including an EV adjustment of -0.3. That helped maintain highlight detail and darken the people in the foreground. As the camera's sensor was less than full frame, the 28mm lens used equalled a moderate angle of a 42mm lens full frame coverage. The RAW file format provided the digital negative from which to work, giving maximum post-capture control. Heather was in Las Vegas while on a short stop waiting for connecting flights. She was watching the fountains outside a casino; the shapes of the different people silhouetted against the water appealed to her as she felt that they made a much more interesting image than just the fountains alone.

enhance

Converted from its RAW format in Bibble software, then to a TIFF file, Heather rotated the image in Photoshop very slightly to straighten the railing. It was then converted to lab colour via Image > Mode > Lab Colour, from its original RGB mode. The three channels of lab colour were then split and the 'L' or lightness channel kept but the others deleted. At this stage the image was converted back to RGB mode. A small tone curve adjustment increased the contrast between the white water and the silhouetted people. Distracting lights at the top of the water were also removed from the building windows using the clone tool.

enjoy

Heather's prints sell online via her Website, and with several local fine art dealers. 'Water Watchers' was supplied as a 17.8Mb TIFF file for our use.

> digital capture
> RAW file
> Bibble software
> TIFF file
> Photoshop
> perspective control
> lab colour
> RGB
> clone tool
> TIFF file

1/ The original image.

2/ Using lab colour.

3/ The final image after manipulation was complete.

Lab Colour Lab colour mode is very useful not only for those using colour but significantly for those working in monochrome. Unlike an RGB or CMYK image, which combines brightness and colour within each colour channel (red, green and blue or cyan, yellow, magenta and black), lab colour mode works in the following way. First the brightness data of an image is placed within its own separate channel called 'lightness'. The colour is then separated out into two others called 'a' and 'b'. The first is for the red\green component and the second the yellow\blue. By separating these out rather than having them linked, you can adjust one aspect without affecting the others. For example, if you have an RGB image but use the dodge and burn tools, changes to brightness also affect the colours. With lab colour mode you can work with these tools in a way traditional darkroom workers would apply the effect. Photoshop uses lab colour as an intermediate reference when converting between RGB and CMYK modes as both can be mapped to lab colour.

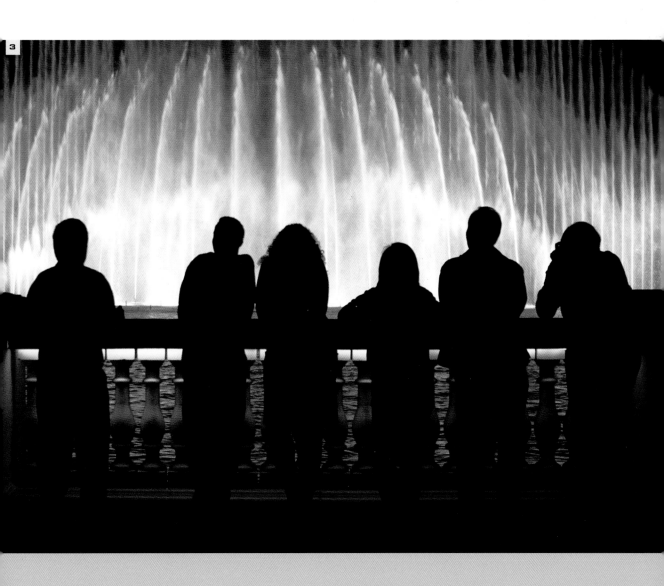

3

shoot

Tony used an all-in-one 5Mp digital SLR to shoot the original image of these garlic bulbs. This was made into a TIFF file and originally shot in camera as a colour image. This high-key still life started with a white silk background on to which the garlic cloves were placed. No doubt a lot of time was spent getting the juxtaposition just right. Tony did not use softbox studio lighting for this shot but rather the available overcast daylight from a window. The exposure utilised the camera's high-quality 80 ISO sensitivity setting, with f/11 as the shooting aperture. Spot metering was also used to carefully measure the exposure.

high key

Tony Perryman is based in the county of Essex in the UK. He has a wonderful portfolio of monochrome images, all either captured or enhanced digitally or both. Many can be seen in this book. It is said that the best post-production is that which you cannot see easily. 'Garlic' is a typical example of creating that effect, but the result is down to the thought process. The resulting 'high key' image is a traditional favourite for those working in black and white.

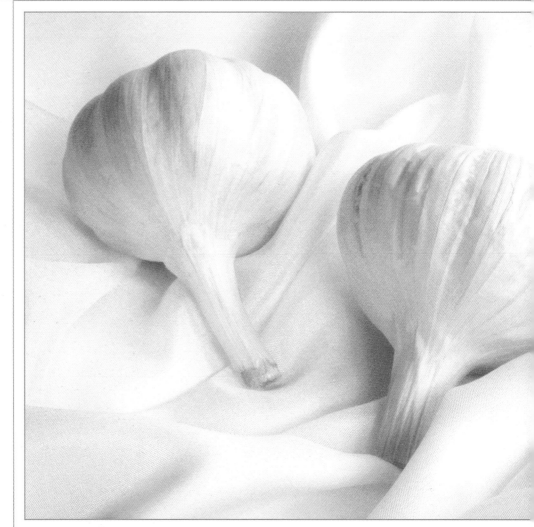

> digital capture

> Photoshop

> hue/saturation

> new layer

> diffuse glow filter

> layer mask

> eraser

> flatten image

> stroke command

enhance

Taking the image into Photoshop, the image was 'colorized' slightly blue using hue and saturation. A new layer was added and the diffuse glow filter applied. Clicking layer mask, Tony then used the eraser set to 100% to cut through certain parts of the garlic bulbs. The layer's opacity was then decreased before he flattened the image and added a border using the stroke command.

1 levels

Channel: RGB

Input Levels: 0 1.00 255

OK
Cancel
Load...
Save...
Auto
Options...

☑ Preview

Output Levels: 0 255

2 stroke

Stroke
Width: 250 px
Color:

OK
Cancel

Location
○ Inside ○ Center ● Outside

Blending
Mode: Darken
Opacity: 50 %
☐ Preserve Transparency

1/ The histogram of the final image shows the high-key bias of the pixels.

2/ The stroke command menu.

3/ The final image.

enjoy

'Garlic' was printed to a final 7 x 12 inch image size. The image is an ink jet print, mounted onto board with double sided tape. A 3\4 inch white border was left and an off-white mount chosen. Tony feels his mono images work best with white\cream mounts. This image has won awards and sold as limited edition prints.

❗ _Stroke Command_ This option allows a soft border to be created. It can be applied to a layer, path or selection via the Edit > Stroke in Photoshop (2). A suitable colour is chosen for the foreground colour, the layer or selection selected and stroke parameters set for the border, opacity and blending.

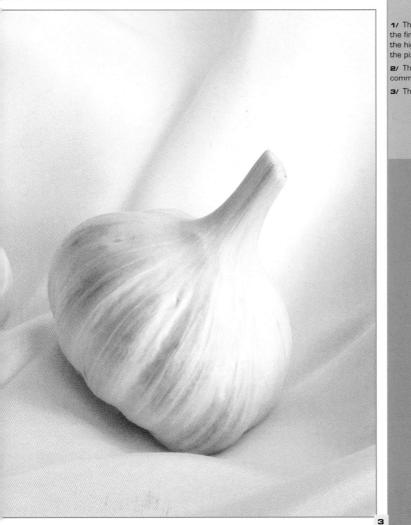

3

5 advanced manipulation

'Home Port' by Bruce Aiken.

This digitally captured image was manipulated to create a 1950s' feel of the South of France. Contrast was increased and the buildings on the shore were blurred to simulate a shallower depth of field. Finally grain was carefully added and contrast adjusted once more.

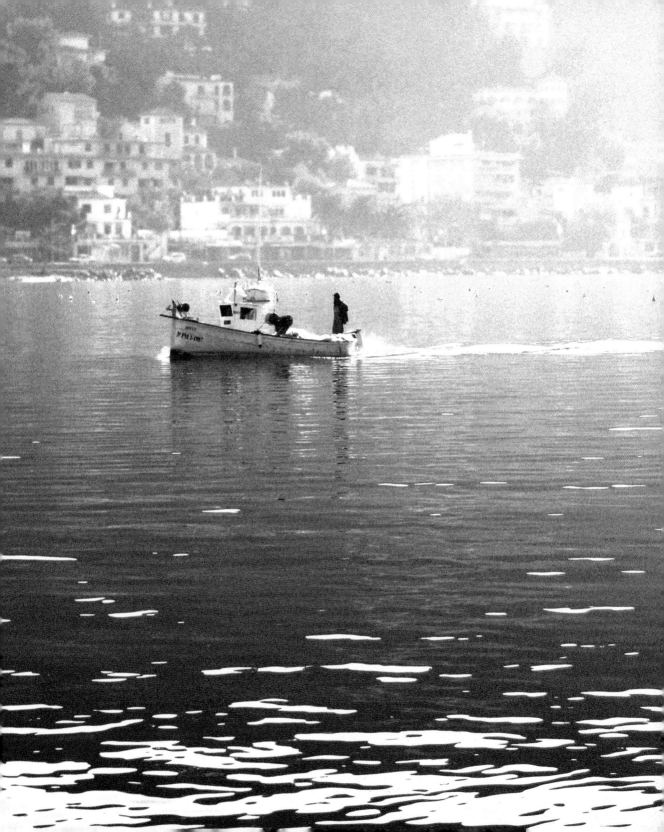

in this chapter

Once the fundamentals have been mastered it is time to create images to be proud of. This chapter looks at the imagery of some advanced practitioners and the more flexible controls.

building an image

Using a variety of techniques the photographer builds his images for successful stock sales.

pages 80–83

adjusting tonal range

Curves are a critical control for deciding on the tonal range and whereabouts various brightness levels are placed. Here we look at one example of their use.

pages 84–87

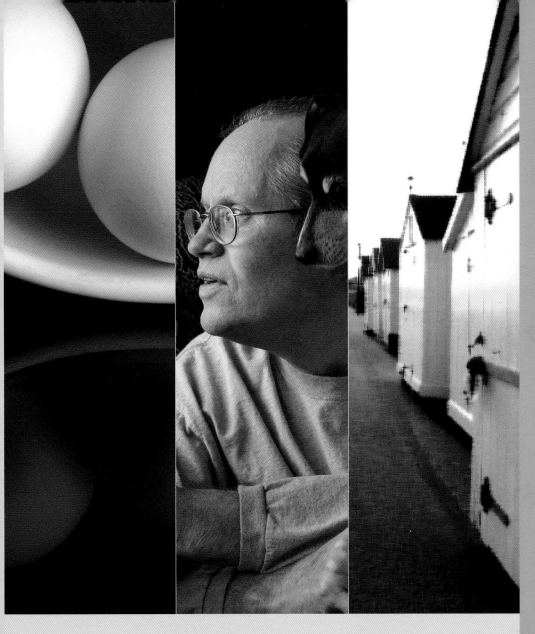

duotones

Working with duotones opens up some wonderful toning capabilities.

pages 88–89

working the image

Step-by-step images are transformed into stunning pictures. Here we show how subtle changes create more impact in the final works.

pages 90–93

digital zone system

The epitome of advanced traditional monochrome photography, here we simplify and rework the concept for the digital capture age.

pages 94–97

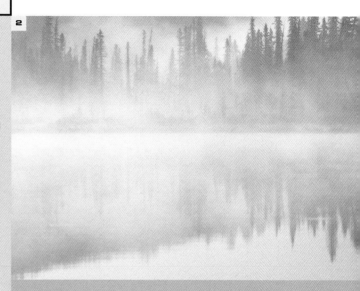

'Don't be afraid to mix and match elements from one shot into another. To do so successfully requires the two elements to be shot in similar kinds of lighting. Here the foggy lake and the dock were both backlit and so the merger looks realistic.'

1

2

building an image

While layers are a fundamental aspect of image production for many, they have their own sub menu of effects that combine to make life even simpler. This image from Darwin Wiggett is one such example.

shoot

While good preparation can significantly increase the chance of getting the shots wanted, nature can sometimes get in the way. This image is a typical example. Shot with a professional 35mm AF camera, high quality 70–200mm f4.0 zoom lens and loaded with a fine grain 100 ISO film, it needed creative post-production to reward the physical effort.

enhance

Photoshop was used exclusively for all post-production after scanning the original. It took around one hour in total at the computer to produce the final image. The original shot of the lake in the fog was captured early one morning near the photographer's home. The day before was hot, but the forecast was for cool temperatures that night. This combination ensures ground fog especially around lakes, so Darwin was up early the next morning to capture the scene. The light was very flat and the sun was obscured by clouds preventing its beams of light from cutting through the fog.

Low contrast owing to the flat lighting was not ideal. Back at base the film was scanned, but to salvage a worthwhile image, contrast needed enhancement to make the fog stand out more. Since the image lacked much colour, Darwin decided it would work best as a toned monochrome shot.

To convert to mono, the calculations command was used. The red channel had the most contrast between the trees and the fog, so was multiplied by itself at 75% opacity. The result was a new image with higher contrast and in mono (2). A

> 35mm film capture
> scan
> Photoshop
> calculations command
> curves
> diffuse glow filter
> hue/saturation
> layer
> transform tool
> layer mask
> RGB TIFF file

'Too often I see mergers where the light on the components merged is discordant. No matter how you enhance the merger, if the light on the two objects is coming from different directions, the merger will look phoney.'

! *Layer Masks* help control the effect of transparency over specific areas. Masked sections remain transparent, while those not masked are opaque. The mask is a greyscale image working over a layer that can be adjusted, depending on the amount of transparency we need. Black is totally see through, white is opaque, and greyscale can be adjusted for varying partial transparency. The effects take place on the mask rather than on the layer itself. Layer masks can be created using the painting or selection tools. In the layers palette a thumbnail appears to the right of the layer icon to show the effect, while a linking icon indicates the mask and layer are joined. A separate thumbnail with a border to the left of the layer indicates that the active layer has a mask ready to adjust, rather than the layer itself. You can remove a layer mask by dragging its thumbnail to the trash icon.

! Always shoot with a tripod (whether shooting film or digital) to get optimal sharpness in your images.

4 diffuse glow

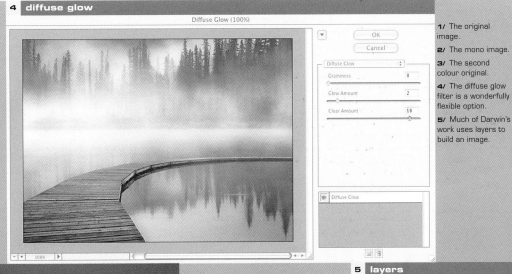

1/ The original image.

2/ The mono image.

3/ The second colour original.

4/ The diffuse glow filter is a wonderfully flexible option.

5/ Much of Darwin's work uses layers to build an image.

5 layers

further increase to contrast was achieved by using an 'S-curve' adjustment in curves. This brightens the highlights, keeps the midtones the same, but darkens shadows. To enhance the fog, the diffuse glow filter was set with white as the glow colour. Grain was set at 0, glow amount at 2, and clear amount at 18 (4). Then hue (210) and saturation (25) toned the image, which was faded back by 50% using the fade command. This version of the image was better than the original, but the photographer still felt it lacked something.

Looking through his files a shot of a curved dock on a lake was found (3). This coloured shot was changed to black and white using the calculation command again, this time using a combination of 70% in the green channel with 30% in the red. An S-curve in the

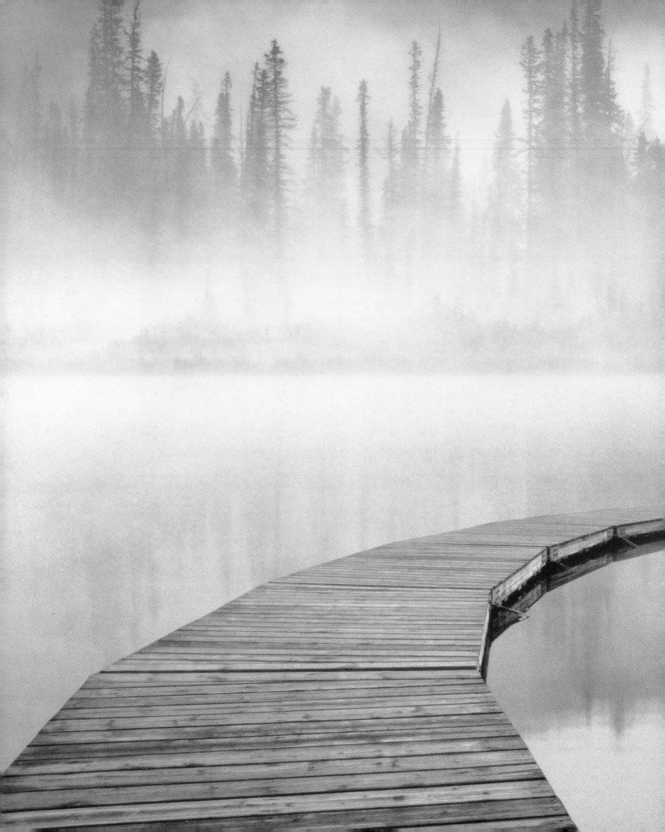

curves control was introduced. Finally, using the same hue and saturation settings as before, this image was toned.

After a rough selection around the dock it was moved into the foggy lake image but on a separate layer. Then transform (Edit > Transform > Perspective) was utilised to alter the perspective of the dock, so it looked better in the foggy lake shot. Once the perspective was right, a layer mask was used to paint away the extra background around the dock allowing a seamless merge with the lake shot. The image was flattened and saved as an RGB TIFF file using the Adobe 1998 colour space.

enjoy

As a stock photographer Darwin finds that 50% of his clients still want film originals. But shooting this has advantages. He can provide either original transparencies or scanned digital files from them. Once the pace of digital capture technology has settled and provides all he wants he will supplement film capture this way. But for now, the 50Mb to 60Mb file sizes his clients want come from film then digital enhancement only.

'I use curves to adjust contrast and think of it in a similar way to changing paper grade in a traditional black-and-white print.'

adjusting tonal range

The right contrast is an important issue in any image, both in the sense of the juxtaposition of elements in the picture and the tonal separation. Here we look at the latter, especially crucial for the monochrome worker to master. There are a number of ways to balance the tonal separation; some are covered elsewhere in the book. Undoubtedly, however, options like curves and the channel mixer are major controls to maximise the effect.

shoot

Felipe Rodriguez using a professional digital SLR and 28–105 lens created 'Fall At Last'. 'I see this place twice everyday: it's on my way to work. I think that you can take better photographs when you are familiar with your setting. This picture was taken on an October day, after a long, hot and dry summertime. Finally the sky was overcast and the temperature went down. I was so happy smelling the rain that I took this photograph.'

enhance

Photoshop was used for post-production. The channel mixer was chosen both to convert the image to mono and adjust its contrast. The red channel darkened the sky and made it deeper; at the same time that also brightened the ground, balancing the picture. This was important as the original had the ground underexposed to avoid clipping highlights and losing detail there. This is a common approach with digital photographs when the scene has such a wide contrast.

curves

Tone curves are not usually the first control people reach for when they start their digital imaging experience; there are easier controls such as levels that can do some of the same things. However, the word 'some' is important. Curves are the most flexible way to adjust contrast. They allow changes in contrast to be made to a specific range of tones or all of them. They can be used for similar effects to simply changing paper grade contrast or using dodge and burn effects in a chemical darkroom. While a single curve works on modifying the brightness of the image, further refinement is possible by using separate curves for each colour channel if you do so before conversion to monochrome if greyscale mode is your preferred route. However, you may find it preferable to adjust curves after conversion from colour to monochrome, which you can do for instance with a desaturated image or the channel mixer.

Opening curves [3] in Photoshop though Image > Adjustments > Curves (or similar programs),

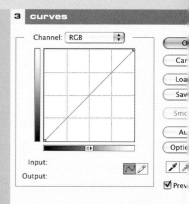

1/ The original image.

2/ The clone tool.

3/4/ Using curves to adjust contrast to a specific range of tones.

! Use the black, white and grey eye dropper tools to set your desired areas to these values quickly.

! 16-bit data even when compressed to 8-bit later, gives more flexibility to adjust tones and avoid big jumps in tonal values (posterisation). This can be especially useful when maximising out shadow detail.

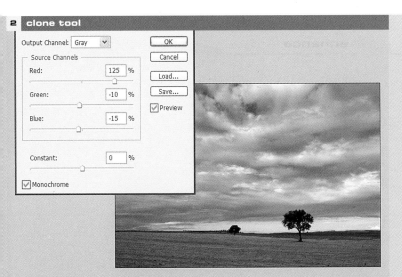

Auto (5) allows a levels, contrast or colour (tone) to be set by the software depending on the settings in 'options'. Likewise, where black is set as standard for the darkest 10% of values and white the brightest 10%, these can be changed if desired.

An 'S' curve (6) is a popular solution to brighten highlights and darken shadows adding contrast to flat images.

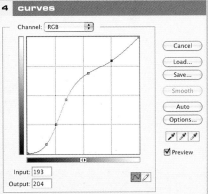

presents the starting non-adjusted curve. Along the horizontal axis are the tones at this stage from shadow (left) through midtones to highlight values (right) for the image. The 45-degree line above represents the curve gaining in height the lighter the tonal value, which is your scale to compare your adjustments against. Likewise, the modified curve positions drop compared to the starting point when darkening the tone. As you move the pointer the input and output boxes allow a numerical comparison of the 0–255 brightness range. If you prefer, the scales can be reversed in terms of highlight to shadow direction by clicking on the adjustment triangles.

Photoshop allows up to 14 points within the tonal range to be locked (4). You can also save and reuse a combination, useful if working on a session of studio shots or as a general curve for modifying say sky and ground relationships such as in this example, 'Fall At Last'.

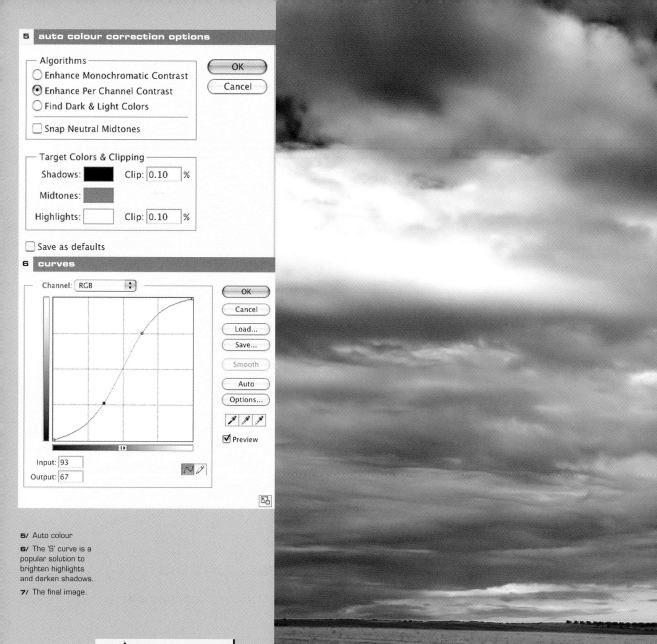

5 auto colour correction options

Algorithms
○ Enhance Monochromatic Contrast
◉ Enhance Per Channel Contrast
○ Find Dark & Light Colors

☐ Snap Neutral Midtones

OK
Cancel

Target Colors & Clipping
Shadows: ■ Clip: 0.10 %
Midtones: ■
Highlights: ☐ Clip: 0.10 %

☐ Save as defaults

6 curves

Channel: RGB

OK
Cancel
Load...
Save...
Smooth
Auto
Options...

☑ Preview

Input: 93
Output: 67

5/ Auto colour

6/ The 'S' curve is a popular solution to brighten highlights and darken shadows.

7/ The final image.

enjoy

As a keen enthusiast Felipe is not so concerned about commercial reward. He has however sold this image but mostly he produces the end product for his own enjoyment.

7

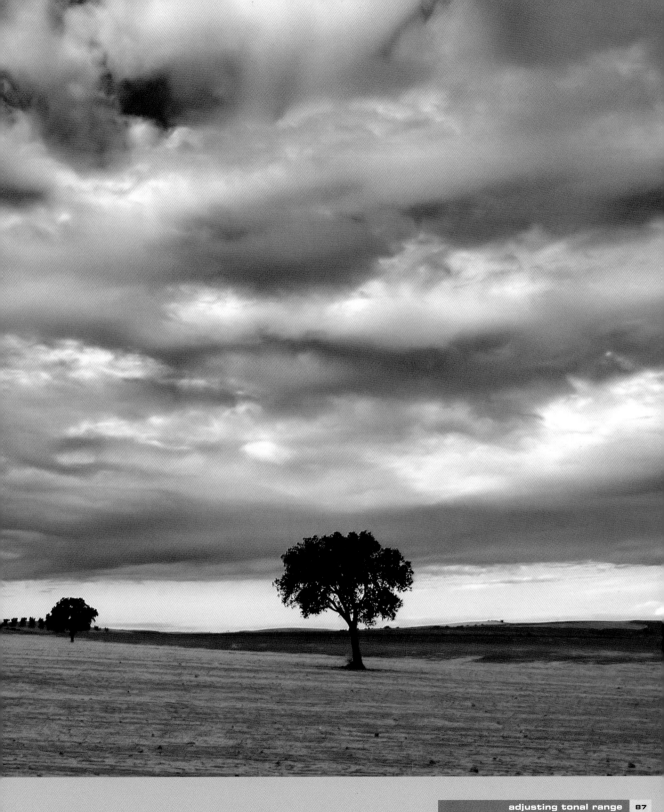

'The camera doesn't make the art, the photographer does.'

1

duotones

Mary Ella-Keith is an artist and photographer. Amongst her repertoire of techniques used are duotones. This is a very versatile way to tone a monochrome image, as in the case of 'Three and Three'. Duotones are widely used in high quality magazine and book reproduction of monochrome images as they extend the tonal reproduction.

> digital capture
> Photoshop
> duotone
> levels
> USM
> TIFF file
> ink jet print

shoot

While most of her work is captured on a 6Mp SLR, 'Three and Three' started life on a 5Mp digital compact, retained for its outstanding macro capabilities. This is something many similar cameras are good at, owing to their small sensor size and aperture combination. Eggs have been an ongoing theme in Mary's still life photography as she appreciates their perfect form and simple elegance. This makes them ideal for monochrome. In this instance a piece of black velvet was placed on a table top with a

2 duotone options

1/ The original image.

2/ Apart from duotones, tritones and quadtones can also be chosen using two or three colours to mix with black. Double click on a colour shown to see the selection swatch.

3/ Colours can be selected in a number of popularly used print tones.

4/ Curves can be adjusted for enhancement.

5/ The final image.

enhance

As a painter Mary of course loves colour, but finds that often a more memorable photographic image comes by using monochrome and duotones. Photoshop is her chosen manipulation program. In this instance the manipulation necessary was kept to a minimum. First came conversion to the rich sepia tone, a minor levels adjustment, then a touch of unsharp mask.

3 custom colours

4 curves

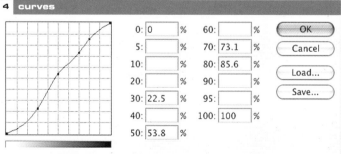

0: 0 %		60: %		OK
5: %		70: 73.1 %		Cancel
10: %		80: 85.6 %		Load...
20: %		90: %		Save...
30: 22.5 %		95: %		
40: %		100: 100 %		
50: 53.8 %				

sheet of glass over it creating a reflective surface. A white vase with an elliptical opening on its side was placed on top. The three eggs, blunt end facing out, were then placed inside, with lighting indirect and natural, her preferred lighting for still life.

5

Mary uses a professional ink jet printer both to output images for her own enjoyment, as well as for exhibition use. She sells images as Fine Art.

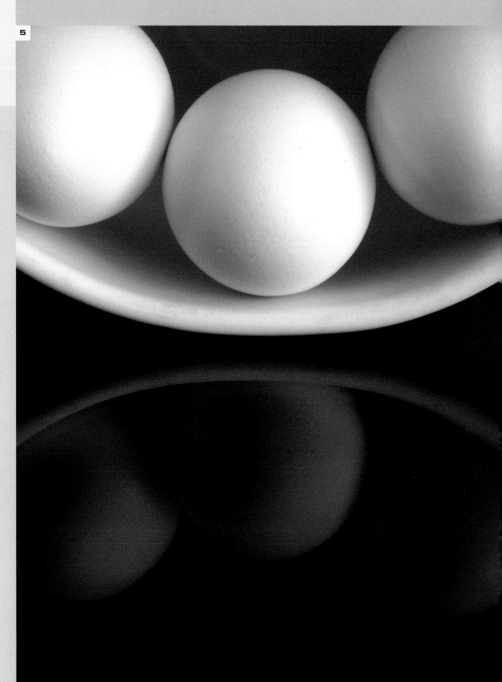

! **Duotones, tritones, and quadtones use two, three, and four coloured inks respectively. These are mixed with black to create tinted greys rather than different colours. Duotones or more are commonly used in high quality reproduction. A standard greyscale image can show up to 256 levels of grey on screen, but a printing press can only deal with about 50 levels of grey per ink. If only black ink is used to produce a greyscale image in print, it can lose the smoothness of the original. Typically adding a coloured ink adds 50 more shades to its printable range, extending the dynamic range, although a tint is often noticeable in highlight areas. When creating a duotone in Photoshop, the image is first taken to greyscale via Image > Mode > Greyscale. You can then activate the duotone option via Image > Mode > Duotone. A dialog box appears (2) allowing selection of colours (3) or manipulation of the component channels through the curves (4). Double clicking on a colour or curve enables changes to be selected and used. Duotones are then saved in the Photoshop format.**

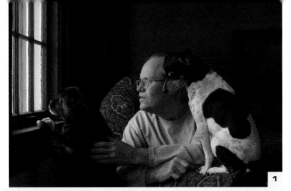

1

working the image

Although an enthusiast, Connie Bagot has also been selling her photography as postcards and has taken portraits for other people. She likes her images to tell a story as with 'The Watch'. No matter what you do, the final use of an image will indicate the steps you have to take from beginning to end.

> digital capture
> RAW file
> Photoshop
> RGB TIFF file
> USM
> layer
> layer mask
> clone tool
> crop tool
> new layer
> levels
> blur tool
> clone tool
> lab colour
> levels
> greyscale
> Grain Surgery plug-in
> CMYK TIFF file

shoot

Connie is based in Ellis, Kansas, USA, and uses a 6Mp digital SLR for most of her work, including this image. This is most often fitted with a 28–135mm image stabilised lens, but there is a 1.5x effective focal length increase on this camera, owing to its smaller than full-frame sensor size. This shot was taken at the 41mm focal length using a 1/10th sec exposure at f/5.6 and a rating of 100 ISO. Taken while experimenting with available light it was created in her living-room. Joe, her husband, was pressed into service and the dogs wanted 'in' on the act also. Connie knows that he and the dogs spend a lot of time 'watching' for her to return home. This image seemed to capture that anticipatory feeling and was intended to be black and white from conception. The original shot was created and saved as a RAW file maximising the post-capture potential.

enhance

Around two hours were spent manipulating this image. The fact that it looks so 'untouched' is a tribute to the quality of work. The RAW image was converted into a TIFF file using Photoshop CS. This program avoided the need to use the camera manufacturer's standard software to develop RAW files as no specific adjustments in that program were required. Default settings at exposure such as white balance were therefore left as taken. The image was then converted to a 6144 x 7096 pixel size, and output resolution set at 240dpi. Connie's first step with virtually all her pictures is a pre-process sharpening to clean up the image. This also increases contrast slightly. Using Filter > Sharpen > Unsharp Mask (USM), values are set for amount 15, radius 50 and threshold 0.

The face of the little spotted dog was a touch soft, so the next step corrected this as much as possible. While an important option, USM cannot do everything, so the in camera image should still be produced

with care. A duplicate layer was created and a further USM of amount 300, radius 2.0 and threshold 0 were set. A 'hide all' layer mask was then created, and using a soft 100 pixel brush at 33% opacity, Connie revealed the dog's face by brushing over the softest portions and blending the edges into the photo. The image was then flattened. Smaller but detailed correction was then carried out utilising the clone tool and various brush settings such as soft, 95% opacity and 100% flow. This cleared up some ugly spots on the window.

Now the image was cropped, and the area of the image that lies to the right of the window frame and above the subjects selected using the magic wand and the lasso tools. A new layer via copy was made. Using levels with input values of 30, 1 and 255, this area was darkened. The effect made the light portion of the wall above the man's head blend into the dark background. The image was flattened again and Connie went over the 'seam' with the blur tool setting a size 37 soft brush (100%) to improve the blend.

! **Work in layers and use soft brushes to create stunning effects.**

! ***Blur Tool*** This tool is one of the many that can make a small but significant difference to an image when used sensibly and with care. Subtle use is the key. It softens hard edges and therefore detail by lowering contrast in high contrast areas or boundaries. If 'all layers' is selected as an option, then the effect takes place on all visible layers. If not, only the active layer is affected. The sharpen and smudge tools share the location in the Photoshop toolbox.

4 | blur tool

| ◊ ▼ | Brush: ● 15 ▼ | Mode: Lighten ▼ | Strength: 50% ▶ | ☑ Use All Layers |

2 | adjusted colour

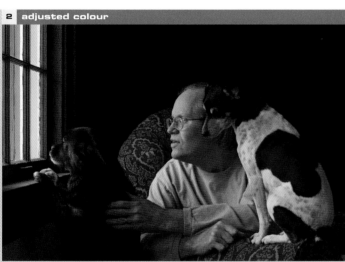

'I like photos that seem to have a story or message beyond just being a realistic capture of a particular scene. Monochrome images seem to leave more room for the imagination, and they often underscore a mood or feeling that simply couldn't be emphasised as well with a colour image.'

1/ The original image.

2/ Intermediate stage adjusted colour image.

3/ Intermediate stage image converted to greyscale.

4/ Blur tool settings.

A few edges at the top of the dog's head still did not look right, so the clone tool (size 30, soft, 95% opacity) was used, selecting the dark area and applying it to the edges of the dog to smooth the transition. The image was saved at this stage.

Changing to lab colour via Image > Mode > Lab Colour, the lightness channel was chosen and the contrast increased by setting the levels input to 0, 9 and 255. A final mode change, this time to greyscale via Image > Mode > Greyscale came next. Then a plug-in (Grain Surgery) was used to remove noise in the image, used at its 100% maximum. The image was saved again at this stage. The image size was then adjusted, keeping the pixels the same but changing the resolution to 400ppi. This is needed for some types of high resolution output. A final sharpening with USM set at amount 100, radius 9 and threshold 0 was made, then the file was saved as an RGB image. For this book it was then converted to a CMYK file (U.S. Web Coated (SWOP)) v2 and saved.

3 | greyscale conversion

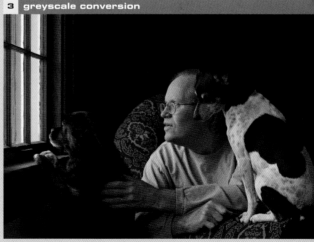

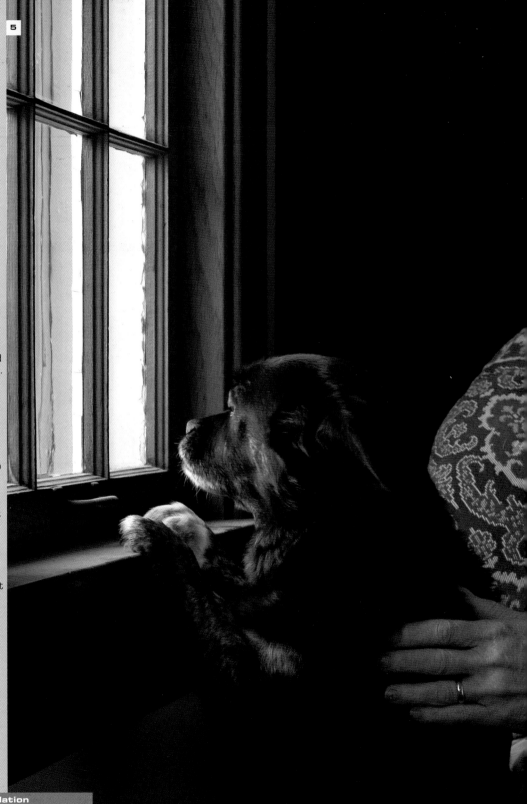

enjoy

Connie used to use an advanced ink jet printer designed for professional proofing to view hard copies several times before getting a final print. Like many of us she found it easier to spot problems on a hard copy than on the screen. This was also relatively inexpensive and could output up to A2 size. Then she started to use a professional dye sub printer designed for desktop use, appreciating the dye sub process for its virtual photographic result. 'I invested in it as people don't want to buy a print that is going to change colour in a couple of years.' However, the costs per print have risen and now Connie is more conservative about what she actually prints and has become much better at using icc profiles and proofing on the screen. The dye sub will output 10 x 8 inch prints.

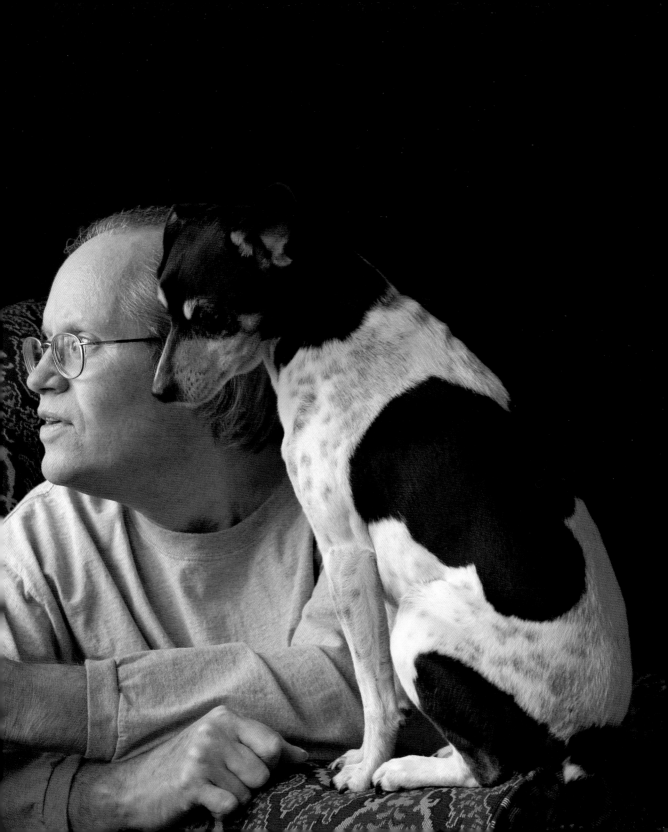

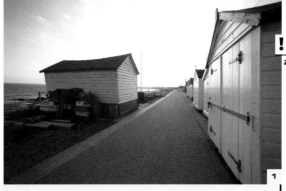

'Using this form of zone system for me puts the "craft" back into my photography and is a welcome alternative to "auto everything" camera usage.'

! As a guide, Caucasian skin is around zone VI, black skin from zone IV or lower.

1

digital zone system

The zone system made famous by Ansel Adams and others has long been the working concept for the most dedicated monochrome photographers. This approach can traditionally be detailed, requiring significant time to come to terms with. Testing various materials and equipment takes time but for many is time well spent. However, while it could fill a book by itself, in the digital capture age, I want to present a simpler approach, based around some of its basic principles. This is specifically for maximising the capture details, although post-capture control has its own ways to achieve quality results. Doing things at the taking stage will however save time. Try it. You will find it quick to use once the principle has been grasped, and it may regularly form part of your monochrome image-making, although this particular approach can also work with colour. For me, it takes away the 'auto' approach so common with modern photography, and once again makes it feel like I am in charge, truly creating my images at the onset in the knowledge of what I am capturing.

> digital capture
> **RAW** file
> **Photo Desk software**
> looks
> sepia
> **TIFF** file
> **Photoshop**
> crop
> crop
> water paper filter
> ink jet print
> frame/mount

shoot

If you take a spot meter reading and expose a film or digital camera, the measurement is designed to reproduce whatever the spot covers for a midtone, a mid-grey result or colour of the same density. This is why we often resort to exposure compensation in camera, as not every subject we meter for is a midtone, or wanted that way. Post-production can also correct for inaccurate metering, but to do so in camera is technically a better option. Therefore knowing that whatever we point the camera at is going to be metered and exposed for this midtone, and knowing that things lighter will need more exposure to make them brighter, while those darker require less to be so, we can use this to our creative advantage. For example, a white shirt needs extra exposure to appear so, rather than off white or grey. Alternatively a black cat needs less exposure than the meter reading suggests. If you use an average or centre-weighted metering system this is presumed to equate the various tones into a mid-grey exposure. Multi-pattern systems are more advanced and are used when speed or ease of

2

shooting is important. The more advanced adjust for colour and tone as well as times when a mid-grey is not best. Both of the latter two offer little or no control for precise measurement from a specific part of the subject or scene. The key to using the zone system is to decide what zone you want your subject to be placed on exposure-wise, then adjust the reading accordingly.

Traditionally the zone system uses ten zones from zone O (black, through various greys) to zone X (white). A zone is written using roman numerals. Zone V is the standard meter reading. I chose the tarmac road to measure as my zone V reading point, expecting detail to remain in the highlights of the beach huts and shadows of the fisherman's tools owing to the wide dynamic range of the camera used. The shot was captured as a RAW and JPEG file of 13,5Mb.

enhance

Opening the RAW file in Photo
Desk software John was looking
to enhance the tranquil and old-
fashioned feel he had of this
Victorian coastal town. For ease,
his camera software had a
wonderful selection of
monochrome rendering options
called 'looks' which enabled him to
make some simple side-by-side
comparisons. I chose the sepia
option to give that 'old worldly'
feel. The image was saved as a
TIFF file and taken into
Photoshop. John cropped the
image slightly and then some
more to first remove too much
space around the beach hut, then
much more dramatically for
impact. This resulted in an image
with the desired 'lazy' morning feel
with no one around. But it still did
not seem quite right so John
played around with some
Photoshop filters. He tried film
grain via Filter > Artistic > Film
Grain after selecting the burnt out
sky area, but that still did not look
right. Then it dawned on him to
go further with the old fashioned
look so he selected Filter > Sketch
> Water Paper (5). That gave a
dramatic look similar to images
taken at the turn of the 20th
century when this area would
have had its heyday.

1/ The original capture.

2/3/4/ The camera
software used gave a
wonderful choice of
monochrome rendering
options. The sepia result
was chosen.

5/ The old fashioned look
was further enhanced using
a water paper filter.

3

4

5 water paper

The development of the zone system is a fascinating story and one that at its most involved uses single large-format film sheets, exposed then processed individually for the desired contrast. This gave the film worker a way to adjust the development aspects to suit the preconceived idea, matching that with paper grade for effect. Roll film users were straight away disadvantaged, as they could not alter development or ISO for individual frames. Thankfully digital capture gives us all the flexibility to capture numerous shots but treat each very differently, nearer the original zone system concept. There have been many photographers who have worked out their own way of working based around the original concept, so why don't you develop your own ideas? The mid-grey (normal) meter reading is always called zone V. Doubling the amount of light reaching a sensor or film (increasing exposure by 1 EV) raises the zone one level brighter or to zone VI. Decreasing the exposure by 1 EV lowers the zone to zone IV from the zone V starting point. Each time we add or take away 1 EV of exposure so we raise or lower the zone one level and number. Two examples would be a +2 EV exposure. When starting at zone V, we end up at zone VII. Lowering the exposure by -3 EV gives us zone II. By deciding what zone the subject should fall on, we make our exposure in the knowledge that we have our subject reproduced as light or dark as it should be, with brighter and lighter tones falling into logical place. This is the equivalent of using exposure compensation in automatic exposure modes, but unlike a bracketed value to judge afterwards the best result, we make that decision with confidence in one single exposure once the concept has been grasped. This not only saves shooting time, but storage space and post-production selection. Once you are used to this approach it becomes second nature and you instinctively start to think this way.

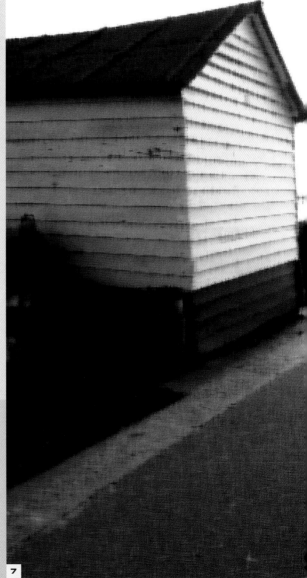

enjoy

This image was printed on to a watercolour ink jet paper from the printer manufacturer to A4, then placed in a dark wood frame with an off-white mount.

7

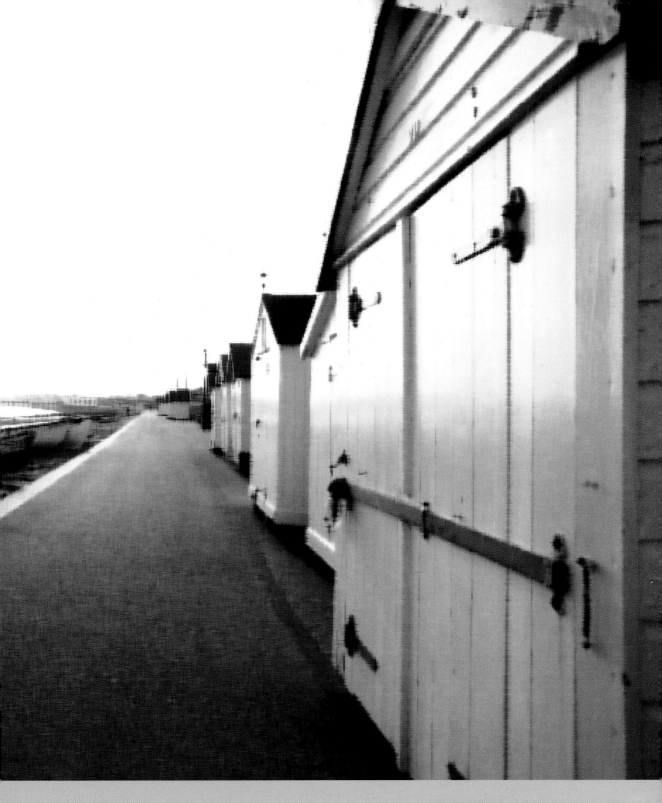

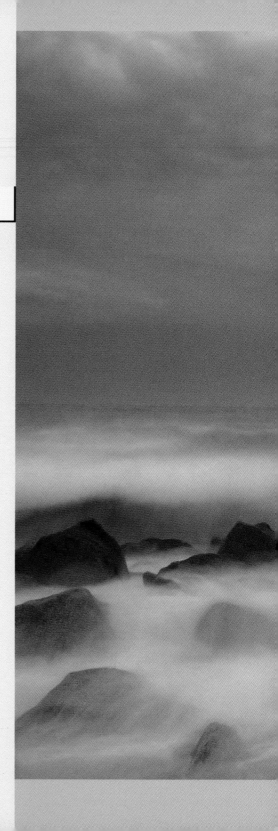

6 extra dimensions

'Pont del Petroli' by Fernando Pegueroles.

An advanced amateur, Fernando Pegueroles based in Barcelona, Spain used a 5Mp digital compact here. 'Pont del Petroli' was taken on a beach early one morning using a tripod-mounted camera with an ND8 neutral density filter and a four-second exposure. Two images were taken with varying effects then combined using layers and layer masks in Photoshop.

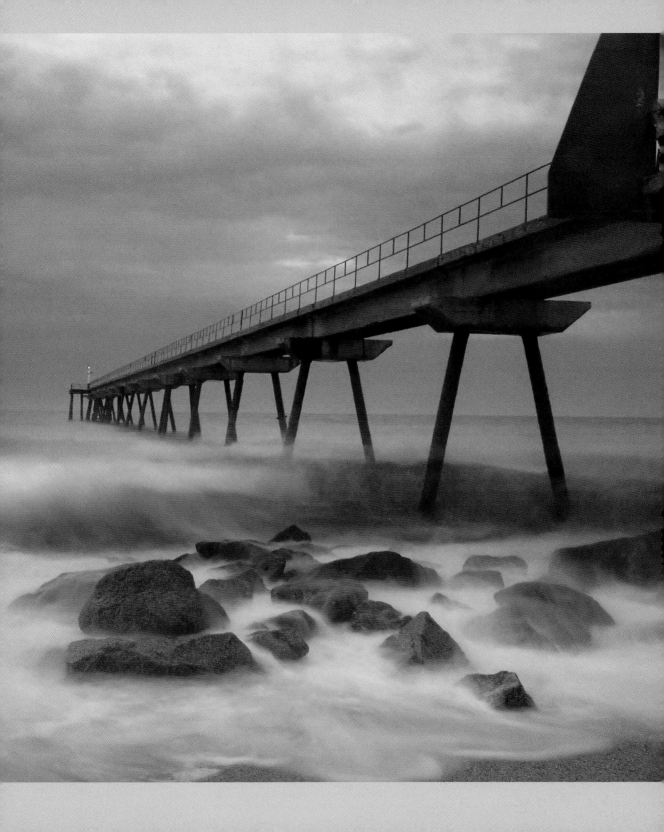

in this chapter

More examples of clever post-capture manipulation and ideas for printed output.

eye-catching enhancement

Sometimes we need to look at images within images to get the best result. Here the photographer has created an image with far more impact by working on a selection of a larger shot.

pages 102–103

alternative capture

Any means to digitise a subject has its role in modern image-making. Here a simple but unconventional approach was used.

pages 104–105

one route to sepia

Sepia toning was always a favourite of wet darkroom practitioners. Here we show one example of how to do it digitally.

pages 106–107

sepia II

A different route to sepia is shown here, combined with other aspects to create a striking result.

pages 108–109

digital infrared

No book would be complete without looking at this stunning aspect of black-and-white photography. It is easier than ever to utilise in the digital age.

pages 110–111

pseudo infrared

Any image can be given a near infrared look if you know how. Here we show how it's done.

pages 112–113

1

Digital artist and photographer Walter Spaeth captured 'Face Close Up II' on a 35mm SLR and 28–135mm image stabilised lens. It was loaded with a 100 slide film and with studio flash lighting.

eye-catching enhancement

Even if you start off with an average looking image, creative post-production can turn it into a mono masterpiece with some relatively simple controls and adjustments.

2 free transform

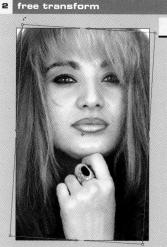

enhance

A desktop 35mm film scanner was used to digitise this image. It was then taken into Photoshop and followed by around 120 minutes' production. The image was converted to greyscale via Image > Mode > Greyscale, then duplicated as a background layer and rotated using the transform command (2). At this stage the image was flattened. The image was then cropped (3) and cloned (4). Image >

4 clone tool

OK
Cancel
☑ Preview

⊟ 100% ⊞

Amount: 38 %

Radius: 4.0 pixels

Threshold: 0 levels

3 crop

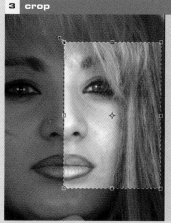

Adjustments > Auto Contrast then gave a better tonal adjustment, followed by manual brightness and contrast control (5). Some unsharp mask was added and the image flipped via Image > Rotate Canvas > Flip Canvas Horizontal.

1/ The original image converted to mono after scanning.

2/ Free transform was used to rotate the original scan.

3/ The image was then cropped.

4/ The clone tool was used for basic retouching.

5/ Brightness and contrast were then adjusted.

6/ The final image showing the creative crop and how the image was flipped.

> **35mm film capture**
> **scan**
> **Photoshop**
> **greyscale**
> **layer**
> **rotate**
> **flatten image**
> **crop**
> **clone**
> **auto contrast**
> **brightness/contrast**
> **USM**
> **rotate canvas**

5 brightness/contrast

Brightness: +17

OK
Cancel
☑ Preview

Contrast: +18

enjoy

Walter makes his own prints on an A3+ ink jet printer using pigment inks, but also sells his work successfully using various Internet gallery outlets.

! **Brightness and contrast adjustments can give many images more impact and are a fundamental part of post-capture. However, they will modify the tonal range so are best used without strong changes unless this is deliberate. Also remember that some types of output will add extra contrast within the process.**

6

alternative capture

Utilising any means to create an image often allows for experimental but interesting results. The flatbed scanner has its role to play, specifically for larger film originals, but what about the scanner itself as the capture device? Tony Perryman did just that with 'Poppies'.

shoot

A flatbed scanner with the subjects placed with a white cardboard box on top was used to start this image off. The image was scanned into Photoshop as a colour photograph with the resolution set at 300dpi.

1/ Gaussian blur filter.

2/ The final image.

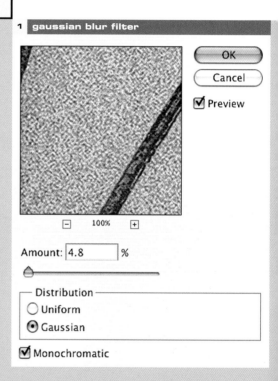

1 gaussian blur filter

OK

Cancel

☑ Preview

100%

Amount: 4.8 %

Distribution
○ Uniform
◉ Gaussian

☑ Monochromatic

enhance

> flatbed scanner
> **Photoshop**
> noise filter
> gaussian blur filter
> hue/saturation
> colorize
> layer
> gaussian blur
> eraser tool
> flatten image
> **TIFF file**

Once in digital form the poppies were masked off so Tony could work on the background. Here he added noise via Filter > Noise > Add Noise. This was then softened using gaussian blur at a low setting. The hue/saturation and its colorize option were used to give the entire image a very subtle yellow/sepia result. Using an adjustment layer, it was colorized almost mono (black). With a soft-edged brush, parts of this layer were cut through to expose the underlying sepia until Tony liked the image. Then a duplicate layer was selected, and gaussian blur added to the entire image at a setting of 10%. Next Tony moved on to layer blending. Selecting 'darken' mode and clicking on the layer mask icon, the eraser tool set to various opacity settings was used to cut through and expose various parts of the underlying image. This was then flattened and saved.

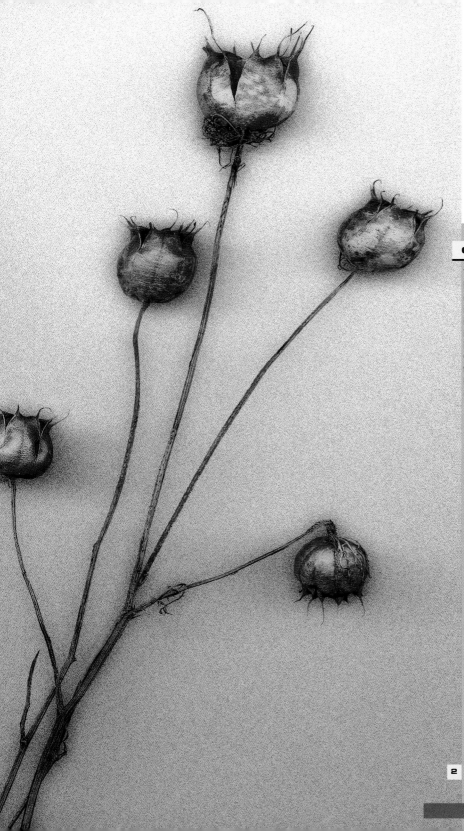

The image was printed on heavyweight matt paper using a desktop ink jet printer to 7 x 12 inch. Tony left a 3\4 inch white border and chose an off-white mount. Most of his images have a keyline printed around them. This work has received awards within the Photographic Alliance of Great Britain and has sold as a limited edition print.

2

Juergen Kollmorgen is currently based in China. 'Tanjung Bidara' started with 35mm film capture, a 200 ISO colour negative 35mm film, and was then converted to digital form by using a 4000dpi desktop scanner.

1

one route to sepia

There are many ways to create toning effects. Sepia results remain much used in monochrome. Here we look at one way a landscape photographer has tackled the task.

'In the digital darkroom I have a second look at the material taken and think of additional possibilities "post-capture work" might offer.'

2 greyscale

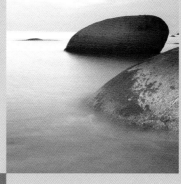

3 channels

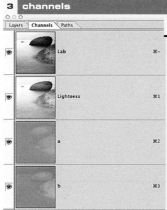

enhance

While Canto Cumulus software is used to manage his digital creations, Photoshop is Juergen's chosen manipulation package. He decided that a square format would work best and cropped the image accordingly. The colour did not work for him, so he decided to convert to monochrome. The process started with Image > Mode > Greyscale (2) and this was copied on to a new file via File > New. At this stage a levels

adjustment was made.

The original image was then restored to RGB colour and converted into lab mode via Image > Mode Lab Colour (3). The channels a and b were then discarded to produce another greyscale image called Alpha 1 (4). Comparing the histograms of the greyscale version and the lab version showed some slight differences in tonality. Next, the lab version was added as two new layers to the temporary file of the greyscale image, followed by minor adjustments with levels.

Different layer effects become the key. The second layer was set to screen and the third layer to Multiply. Juergen then experimented to determine which opacity and fill percentages were best. A gradient map was created as another layer to add the sepia tone. The last step added a curves adjustment layer to change the tonal range. Returning to the opacity and fill settings for each layer, some fine-tuning was made. The layers were then flattened.

4 channels

> 35mm film capture

> desktop scanner

> crop

> greyscale

> levels adjustment

> TIFF file

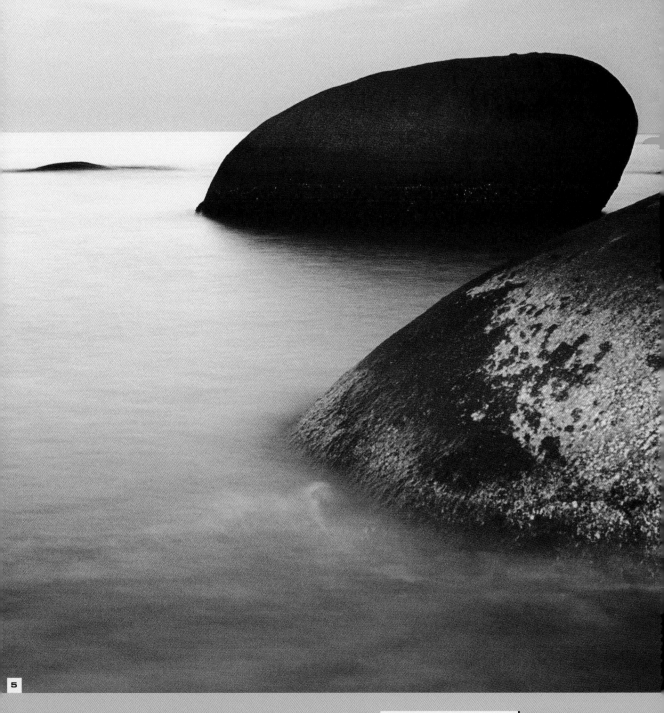

5

1/ The original film image.

2/ The scanned greyscale image cropped for effect.

3/ The original image taken from RGB mode into lab colour.

4/ Two channels from lab colour are discarded leaving one greyscale channel.

5/ The final sepia-toned image.

enjoy

Juergen exhibits his work. The image was sent via FTP for our use.

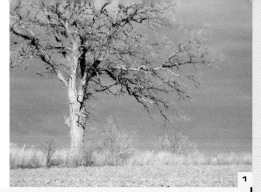

1/ The original in-camera capture.

2/3/ The intensity of NIK Color Efex Pro software's graduated filter was adjusted for effect.

4/ The arbitrary command in Photoshop was used to rotate the image.

5/ The final image.

sepia II

Tess Campbell is based in Oostburg, Wisconsin, USA. Here we look at another way to create a sepia image. The tree in the photo is one of her favourite subjects, an old oak that stands at the edge of a farm field near where she lives.

shoot

The camera used for this image was a 2Mp model, set to record in sepia mode, but with the addition of an infrared (R72) filter for effect. However, there was a lot of work to do in the digital darkroom to get the image Tess wanted.

enhance

Tess used Photoshop with plug-ins NIK Color Efex Pro, Flaming Pear flood filter and Flaming Pear silver filter, in the production of this image. The original shot needed straightening so this was achieved using Photoshop's arbitrary command, set to move 1 degree clockwise (4). It was then cropped and brought back

to its original size and saved. Next the Flaming Pear flood filter was applied at settings of horizon 94, offset 0, perspective 70, altitude 90, waviness 25, complexity 13, brilliance 49, blur 12, ripple size 96, height 20, undulation 3, and glue normal. Now came the application of the plug-in filter NIK Color Efex Pro's 'old photo filter'. The settings were for brightness 1%, grain 12%, paper colour 107c, contrast 100%, and the channel slider set to all. Then Tess applied NIK Color Efex Pro's graduated 38h

> digital capture

> Photoshop

> arbitrary command

> crop

> Flaming Pear flood filter

> Color Efex Pro old photo filter

> Color Efex Pro graduated 38h (warm yellow) filter

> curves

> Flaming Pear silver filter

> 8 x 10 inch print

(warm yellow) filter with a setting to rotate the horizon 180 degrees, filter opacity set at 35%, shift vertical 50%, and blend 15mm. She then adjusted the contrast using Photoshop's 'curves'. Values were placed for RGB input at 113 and output 147. The final look was achieved by added the Flaming Pear silver filter with values of blur 90, edges 37, bands 96, dots 11, checkers 62 and glue multiply. About an hour was spent working on this photo post-capture, part of that time just playing with different settings.

Tess has printed this image to an 8 x 10 inch print size using an ink jet printer with dye rather than pigment inks. Her favourite paper is the manufacturer's heavyweight matte. The image is housed in a black core, rust-toned and acid-free matte board, fitting into a simple semi-gloss wood frame with outer dimensions of 11 x 14 inch.

5

Image Making While conventional photography uses the 'visible spectrum', it is part of the invisible spectrum that we need to use for infrared, or near infrared photography. Specifically filters deep red or near opaque in appearance are used to filter out all except light around or above 800nm (nanometres) in order to completely block other parts of the colour spectrum. These can be placed anywhere in the light path, but usually over a lens. Our camera's sensor if sensitive to infrared wavelengths will then record the characteristic surreal effects with the larger infrared-reflecting subjects appearing white, while those with no significant reflectance are black. In comparison the visible spectrum ranges between 400nm to 700nm. Digital infrared plays a big role in digital monochrome.

digital infrared

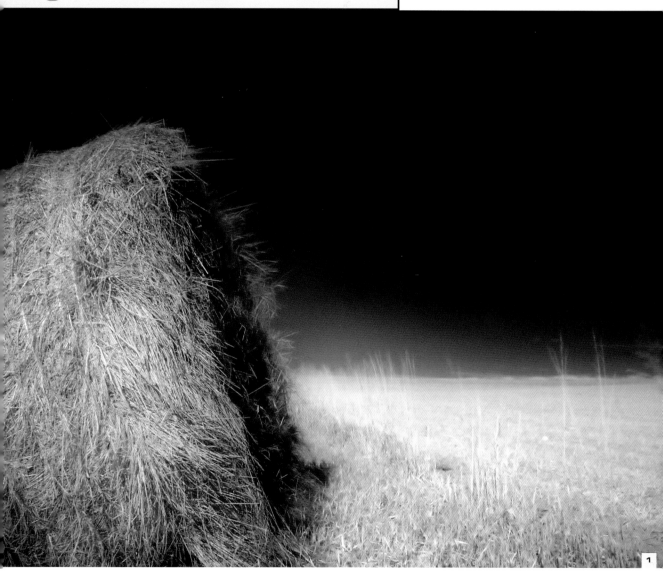

1

> You can get an idea if your camera is suitable for IR imaging by using a TV remote control in a darkened room making a long exposure. The infrared beam projected will record on a suitable camera.

> You can capture infrared images with the camera set to normal RGB colour as well as monochrome mode. The first will give a colour cast that can be removed by some third party software or numerous options within Photoshop and similar programs. For instance, using the white eye dropper tool to click on to something that should be white will generally clean up the image and remove a cast. If need be do this on various areas if the effect is being stubborn.

2

shoot

Connie Bagot combines her passion for photography with some sales, putting her in the semi-professional category. Digital infrared photography is a wonderfully creative approach to image-making, giving eye-catching but other worldly effects. But you do need to concentrate and get all aspects working properly to get the most from it. In this aspect of image-making using digital capture is easier than film and opens up infrared photography to many more people.

> digital capture

> B&W capture mode

> 72R filter

> TIFF file

> Photoshop

> USM

> layer

> brightness/contrast

> Grain Surgery plug-in

> gaussian blur

> high pass filter

> dye sub print

Connie uses an advanced specification 5Mp digital compact for all her infrared images. Not all digital cameras are suitable, some will block out the effect, which is understandable for normal and conventional image-making needs. However, with a suitable camera and an infrared light-transmitting filter (Connie uses a Hoya 72R), the effect can be utilised by transmitting light in the infrared or near infrared to the camera's sensor. Connie sets black-and-white capture mode. This photo was taken during the month of November when she was actually looking for a few trees that still had leaves to take a few infrared (IR) images of. Foliage (preferably young) is very good as a subject for showing IR effects. She spotted an interesting arrangement of hay bales and began shooting quite far back initially to include several of them, before moving nearer for this close up. As the filter absorbs a lot of light, the exposure was made at 1/4 sec at f/8 using 100 ISO sensitivity.

3 unsharp mask

OK

Cancel

☑ Preview

⊞ 100% ⊟

Amount: 15 %

Radius: 50 pixels

Threshold: 0 levels

1/ The final image with 'infrared' look.

2/ The original capture.

3/ A subtle use of the unsharp mask.

enhance

About an hour was spent in Photoshop working on this image. It was straightforward to process. An initial USM was applied (amount 15, radius 50, threshold 0) and the image was separated into three layers; one for the grass, one for the sky, and one for the hay bale. The darkness of the sky was increased and the grass lightened. As for the hay bale, it was lightened but also had its contrast increased. The aptly named plug-in Grain Surgery removed noise from the sky and the grass. Then a light gaussian blur was applied to these areas, catching the edges of the hay bale also. The hay bale was then sharpened using the high pass filter (Filter > Other > High Pass).

enjoy

Connie uses a dye sub process to produce images with a continuous tone like one can achieve with silver halide printing. Infrared images often look good as large prints framed in a black finish with suitable mount colour to match the image.

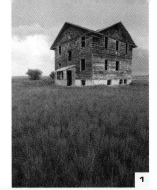

1

'The diffuse glow filter can be a magic lifesaver to give your images atmosphere, or make them look like they were shot with infrared film. I like to tone my images by colouring the highlights and leaving the shadows neutral. This makes the images more three dimensional.'

pseudo infrared

Something out of nothing? Not quite, but with imagination, technical understanding and a little time, otherwise redundant images can become worthwhile images. Take a look at how Darwin Wiggett reworked an unpromising original into a high quality monochrome shot.

shoot

For this shot called 'Old House in Field', Darwin relied upon the technical quality of a 6 x 4.5cm professional roll film camera, loaded with a chromogenic (C-41 colour process) monochrome film. This is normally rated at 400 ISO. A 45mm lens was used, slightly wide angle in effect. The original image was shot in Robsart Saskatchewan, a town mostly full of abandoned buildings with only a few people living there today. It was overcast and Darwin felt the building might look best if shot in monochrome. The negatives were filed away, with the idea one day of making a print in the darkroom. That day never came, as Darwin sold his chemical darkroom when he switched to a digital one.

enhance

Many years later he found the negatives again and decided to try some digital work on the image. This particular emulsion scans with a lot of patterned noise on his scanner, so much so, that Darwin almost stopped there and then due to the pronounced noise. But deciding to tackle the problem, a duplicate layer of the image was created in Photoshop, then a 20-pixel gaussian blur was applied on the duplicate layer. This was blended with the non-blurred original by setting the blending mode to 'darken' and reducing the opacity of the blurred layer to 50%. This helped eliminate the white speckled noise in the image giving it a slightly painterly look. However, the grass looked flat and lifeless, so it was selected using quick mask and a diffuse glow filter applied via Filter >

Distort > Diffuse Glow, with settings of white for the glow colour, 'grain' at 0, 'glow amount' at 10, and 'clear amount' of 12.

The result looked slightly like the effect shot on infrared film. The house was then selected and the diffuse glow filter applied with the same settings. These were then faded back to 30% using the fade command. The image was then converted to colour, Darwin then CTRL-clicked on the blue channel to give a selection for the highlights in the image. This was then coloured using hue/saturation set for the 'colorize' option. In this case the settings were hue 30 and saturation 25. Shadow areas were left uncoloured giving the image more dimension. This took around 30 minutes to complete.

> medium format
 film capture
> scan
> TIFF file
> Photoshop
> layer
> gaussian blur
> quick mask
> diffuse glow filter
> hue/saturation
> colorize
> RGB TIFF file

2 diffuse glow

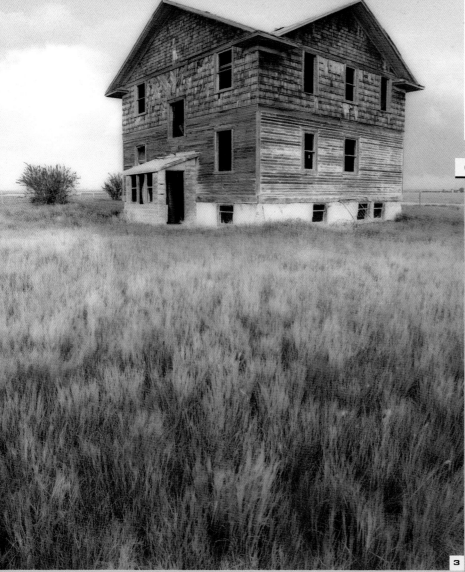

! As a guide, a **50Mb to 100Mb** file is required for stock imagery.

enjoy

As mentioned with his other work in this book, Darwin shoots for stock. However for our needs the final image was supplied as an 8-bit RGB TIFF file at 300dpi, totalling 98Mb of data, and with an Adobe 1998 colour space embedded.

3

'I have a difficult time visualising in black and white and hated all the developing options with monochrome film and prints so I only shot black and white occasionally. Now I can shoot everything in colour and later in the digital darkroom check to see if it will translate well into a monochrome image.'

1/ The initial monochrome film shot.

2/ The 'diffuse glow' filter can help create an infrared effect.

3/ The final toned and pseudo infrared image.

7 presentation

'Day's End' by Bruce Aiken.

This is the first image Bruce made when
he started digital photography. An
experimental blending of duplicated layers
enhanced the cloud formation. The couple
were enlarged and moved from their
original position much further down
the beach.

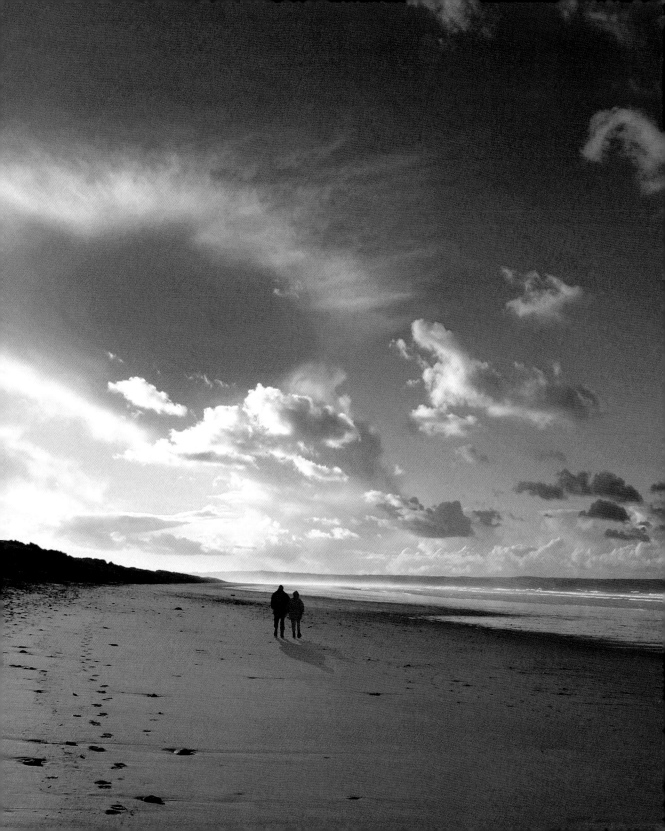

in this chapter

How your work is presented will
have a lot to do with its success.
This chapter looks at various ways
photographers go about it.

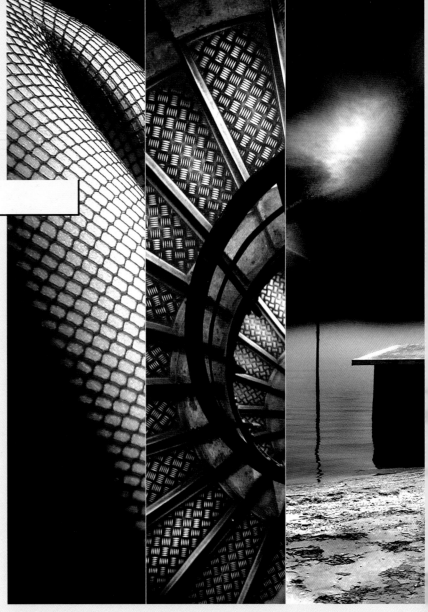

looking good

With a definite concept of
what the photographer
wanted to portray and why,
this spread details the
story of the shot from
beginning to end.

pages 118–121

looking good II

A further example of the
photographer's work
detailing the story behind
the shot and its final
destination, plus an
interesting idea also for ink
jet printing without colour
management.

pages 122–123

selective contrast

Dodge and burn
techniques were common
in traditional darkroom
work. Not used as widely in
the digital domain, this is
however an option that has
plenty to offer.

pages 124–125

dye sublimation

An increasingly popular alternative to ink jet or silver halide output, this spread looks at this choice and also shows a dramatic nude, a timeless subject for the black-and-white photographer.

pages 126–127

adjusting your canvas

Changing the shape of your images can offer more attractive images. Here the straightforward task is considered in one form.

pages 128–129

panoramic prints

Modern cameras and post-production options have rekindled interest in the panoramic image. Here we detail one fine example.

pages 130–131

fine art photography

We could not overlook the ultimate quality that qualifies as 'fine art'. Both in approach to capture and materials used for making longevity prints, this is a most interesting aspect to black-and-white photography.

pages 132–135

'Fishnets are definitely a sex symbol as well as a symbol for entrapment. In this picture the net confines her legs, which are poised in a somewhat tangled position. The buckled ankle straps on the shoes serve as another binding element in the photograph. The woman's individuality and personality are completely unimportant, illustrated by the absence of her face or distinctive features.'

1

2

looking good

After all the hard work it seems a shame not to present images in an eye-catching and practical way. For many photographers the **CD or DVD** is a viable alternative to sending images via the Internet. It's slower, but not everyone has the ability to send or receive large files at a practical speed for electronic transmission. However, many find that storing the images, both the final and the digital negative, on such materials a practical and safe method. This is arguably more secure than on a hard drive. However, you still need a way to identify the contents quickly. But that's not all. There is no denying the fact that a final print is hard to beat. With the popular ink jet temptingly available at a reasonable cost, how do you get the best from it? Jenny Taylor has developed her own ways of using such options. A graduate from the University of Texas with a Bachelor of Arts in Studio Art, her knowledge covers computer art media, photography and art history.

> digital capture

> JPEG

> Photoshop

> layer

> levels

> channel mixer

> crop

> levels

> TIFF file

> CD

> ink jet print

shoot

'Caught In The Net' was produced to make a visual statement about modern woman. 'I am interested in the placement of women in society, especially in today's world where we are far more open about our sexuality.' As a professional photographer and artist, Jenny's preferred choice is a 6 x 6cm film camera or 6Mp digital SLR with interchangeable lenses. However, this image was created on a compact digital. It was set for manual exposure control, with an aperture of f/2.0 using 100 ISO sensitivity and a focal length of 7mm.

Shot in her apartment using a basic lighting set-up, this image needed quite a bit of Photoshop manipulation to get to the final image, between 1–2 hours in total. 'Popular TV programs show liberated women that are continually binding themselves in tight shirts, revealing skirts, and ankle strap stiletto heels. Despite the fact that women are liberated, we consciously choose this binding clothing to attract the opposite sex. This contradictory behavior just puts us back in a submissive position in life.' So how to say all that in an image?

enhance

Jenny gets better results using the channel mixer in Photoshop for monochrome.

She likes the way it seems to dither the grey tones less, and gives great control over highlights and shadows. Her usual approach is to decrease the blues quite a bit and add more green and red. The effect tones down some of the harsher highlights, adding more detail also. Interestingly, usually two completely different edits on an image are made depending on whether or not it will be displayed on paper or a monitor. Higher contrast images usually look better on a monitor, but lower contrast, less sharp images usually print better. Image adjustments using layers is standard practice. Jenny usually has a level layer, a channel mixer layer and so on, making it easy to 're-tune' the image for different media. Having level adjustments placed on different layers makes it easier for Jenny to adjust settings so they don't destroy an image. For this shot the channel mixer was used to make the image monochrome, then a crop to improve composition was made. Finally, contrast was adjusted for effect.

'During college, I spent quite a bit of time practicing traditional photography techniques as well as digital. After taking several Photoshop courses and using ink jet printers for output, a digital camera and a printer became my tools of choice for capturing and displaying my ideas.'

! *Labels of Impact* Jenny prefers a glossy finish label. Labels and centring devices can be bought together, making it easy to attach the labels to the CD without wrinkling. She archives work with these labelled CDs, and always prefers giving a nicely printed CD when showing work to anyone else. As she puts it: 'A photographer's main goal is to present their image well. In today's digital world, many photography galleries are online or on disks. The same care in displaying those images should be taken as it is when a photographer displays their work in a real gallery.'

Caught In The Net

Descending

Images by Jenny Taylor

3

'People have so many burned CDs that get shuffled around on their desks these days, and it is so easy to lose track of the CD's content. These labels make the disk's content very clear and it is a nice way for an artist or photographer to present their work.'

1/ The original image.

2/ The final image.

3/ 'Caught In The Net' and 'Descending' were both images supplied for this book in an eye-catching way.

4/ An example of a printer.

5/ Monitor profiling is vital for consistent results. A 'spyder' like Eye-One is an advanced way of achieving this.

ink jet prints

There is no doubting the popularity of ink jet printing. Such printers range from the desktop general-purpose unit to large free-standing devices often used in studios and by designers. The pros and cons range between those dedicated to them and those not so sure. There are a number of factors to consider. First is ink type. The choice falls into two camps. Dye or pigment? The benefit of the first is generally a greater colour gamut and more products to choose from. The drawback is that under simulated testing, a dye-based image does not last as long as one made up of pigment colours. Technology is moving ahead all the time, so it pays to keep up to date with the claims. Importantly, it may be worth investing in a 'giclee' ink jet print if you want more confidence of longevity. It is usually the environment, air and humidity that play havoc with print colours and deterioration.

4

getting the tones right

As with colour work, the best monochrome prints come from using a calibrated monitor under controlled conditions. At one extreme, special software will measure your monitor's response to 'target colours' when a device called a 'spyder' is attached to measure this physically. Guidance based on the feedback will help calibrate your monitor, which should be done on a regular basis – my suggestion is once a month at least. The next best means if you don't have such a device is to use your computer's software calibration system. However, to put things into the right context, proper viewing conditions mean constant lighting anytime of day, neutral grey walls and the photographer wearing black so as to avoid reflecting any colours on to the screen. That is not practical for many, but it's best to experiment with the equipment and conditions you can control. If you operate in a 'closed loop' then it is easier to reach a predictable level of matching the on-screen image with the final print. Such a system means that you have input through to output control such as when making your own prints.

5

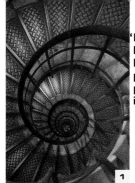

1

'I also add a greenish brown channel mixer layer to neutralise the purple cast from ink jet prints. They turn out incredibly neutral!'

'Different papers have dramatically different colour adjustments. This is a crude way of doing things, but college students will always find the most economical way! I have surprised many people with the results who

figured I was using expensive calibration software. However, unless you have a printer full of greyscale inks, you will still see a minor colour cast in the best black-and-white ink jet prints.'

looking good II

The Closed Loop. An alternative idea comes from Jenny Taylor again. She mostly produces 12 x 18 inch or 12 x 12 inch prints on her ink jet printer using dye technology. Importantly this is a 'photo' printer and not a general-purpose unit. Maximum option is a borderless 13 x 19 inch print. These are mounted and framed with a three-inch wide white overmat, with a one-inch wide black frame. Rather than using a spyder, she uses software calibration for her monitor supplied within the computer. Jenny then makes tests with different paper types on her greyscale images. For each paper type she prints out an image and has made a colour adjustment layer to neutralise any colour cast. She simply opens her colour file and drags the adjustment layer for the paper type to it.

shoot

This shot was captured in the Arc de Triomphe, Paris, France. Jenny was inspired by the never-ending presence of the staircase, the texture of the metal and the cement. The camera settings were interesting. Using her 6Mp interchangeable lens SLR, fitted with a zoom lens, the focal length selected was 30mm. But an 800 ISO sensitivity, 0.5-second exposure and an aperture of f4 were needed to combine the visual capture with her idea of how the shot should look. The channel mixer converted the image to monochrome, with some contrast adjustments to make the black more dramatic. The clone stamp fixed distracting flaws in the staircase, and softened some harsh light reflections from the metal.

! The use of small gamut mono inks is a must for those looking at an alternate route to high quality output using ink jet technology. These inks comprise numerous shades of grey, plus black and replace the normal colour cartridge. Both OEM manufacturers and third parties provide these for various printers. Some such as Lyson also offer a proofing and calibration service for your printer and monitor under your working environment.

enjoy

Jenny makes ink jet prints for exhibition, but this image was supplied both as an RGB and CMYK TIFF file, burnt to CD with thumbnail images on its face to make an impressive product presentation for inclusion in this book.

> digital capture

> channel mixer

> contrast adjustments

> clone stamp

> RGB and CMYK TIFF

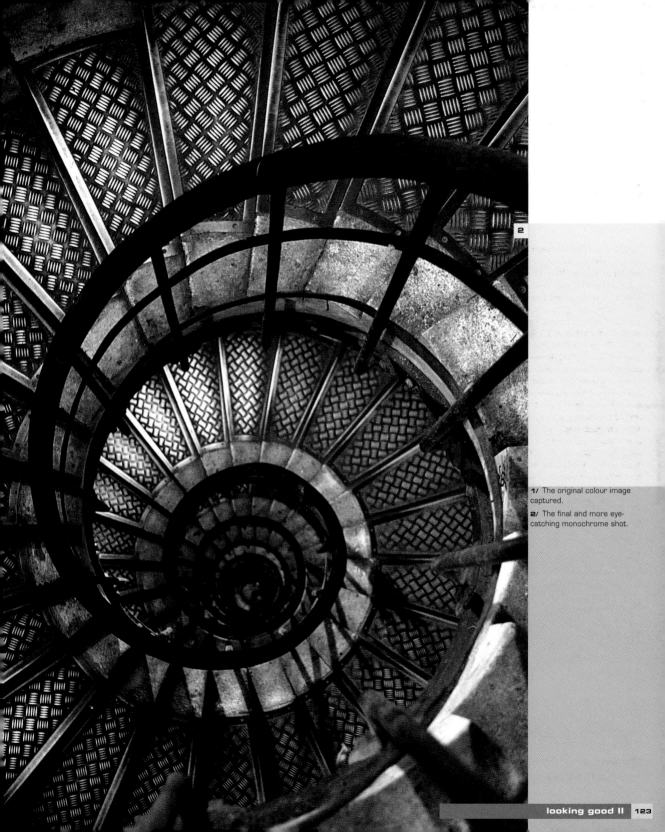

2

1/ The original colour image captured.

2/ The final and more eye-catching monochrome shot.

'There's a mystery, power and intensity to monochrome images that I've found very difficult to capture using colour. With the colour values absent, I think it's easier to emphasise the lines and contrasts in the image.'

! *Dodge & Burn* When Jeff uses dodge and burn, he likes to think in terms of a battle between light and dark. He goes back and forth between the dodge and burn brushes over the same area, alternately brightening and darkening. This can give the image a harsh look, which adds to the drama.

selective contrast

Jeff Alu uses purely digital capture. Widely published, his work features high contrast, both in look and feel. His preferred approach is to let his imagination take him on a creative journey. But it is the modern digital techniques of dodge and burn, so at home in a 'wet' darkroom, that he calls upon most.

shoot

Jeff shot these images with a 2Mp camera, but recently upgraded to a 5Mp model. These shots were taken at the Salton Sea in California on two separate occasions. The shack (1) is an abandoned restroom and the surrounding area was covered with dried mud. Only a couple of inches down from there was a black and warm layer of wet mud. His shoes and lower legs, almost up to his knees, were unfortunate enough to make contact with this mud, possibly full of pollutants and rotting fish. There are a lot of dead fish at the Salton Sea, not because of the pollution, but because the sea is running out of oxygen due to the warm temperature of the water and the algae that consumes oxygen. The second image was captured at a later date about 200 feet away from the first. By the second date, the mud had dried completely. A very hot day, 105 degrees, this type of weather usually makes Jeff feel very relaxed, probably because he has to move slower than usual. He thinks the hot weather is what put him into the state of mind ready to take this dream-like shot.

> digital capture
> Photoshop
> channel mixer
> greyscale
> burn tool
> USM
> dodge tool
> ink jet print

enhance

Photoshop is used for all his post-capture processing, specifically the channel mixer, dodge and burn brush, and the unsharp mask plus sharpening filter playing significant roles. The first shot, called 'Far 1', was a RAW image, shot at 1168 x 1760 resolution. Next the image was converted to greyscale (2) using the channel mixer with the monochrome box ticked. The red channel was set to 0 and the green channel to 100. This reduced the noise that was visible in the sky. Then a small amount of

Experiment with the unsharp mask in **Photoshop**, especially the radius parameter. It can really make your image 'pop!'.

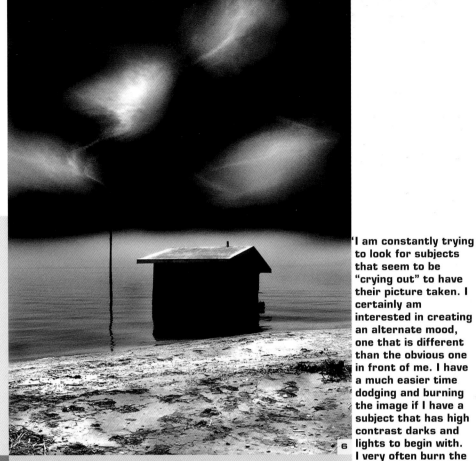

burning was carried out on the sand, water and house (3). Further dodging and burning of the sand was followed by burning out detail of the sky where there were no clouds (4). With the range set to 'shadows', the bright clouds were safe from being burned out (5). A touch more burning in on the sky was followed by some unsharp mask (large radius), to make the image more intense. The last stage was to dodge the sand to make it brighter (6).

5 burn tool

1/ The original image.

2/ The channel mixer was used to convert the image to mono.

3/ The sand, water and house were 'burnt' in.

4/ The cloudless areas of the image were changed with the burn tool.

5/ The dodge and burn tools can be set to work on specific tones only.

6/ The final image.

enjoy

Jeff makes prints for exhibition purposes. He uses an online printer to make digital prints. Sales are mostly to private individuals, but of course there are quite a few prints hanging at his home. Jeff uses www.digiprintstore.com. At home, ink jet output is quickly placed under glass and framed (about 15 minutes per image). Sometimes, if he is not happy with the way an image turns out, he goes back (usually a couple of months later) and tries again. He doesn't like to think about the image too much while he's working on it.

'I am constantly trying to look for subjects that seem to be "crying out" to have their picture taken. I certainly am interested in creating an alternate mood, one that is different than the obvious one in front of me. I have a much easier time dodging and burning the image if I have a subject that has high contrast darks and lights to begin with. I very often burn the shadows totally black, since often, areas in the shadow will contain low-contrast objects that only serve to interfere with the overall composition of the shot.'

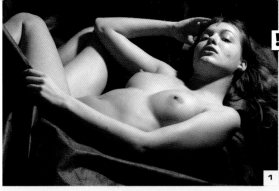

! Compose in
camera at the
time of shooting.

! Dye sub printers are now
available to fit on the desktop.
They are large and heavy, but that
is down to the construction
needed to allow all the mechanical
components. The process uses a
receptor paper that is coated
individually by cyan, magenta and
yellow ribbon. This is heated to

1

dye sublimation

2

While ink jet printing
has taken much of the
limelight recently as it
has opened up digital
printing to virtually
anyone, the technology
is still being refined.
Some would say that a
restricted tonal range,
longevity concerns and
slow output speeds are
the downsides to this
otherwise useful option.
But there is an
alternative that has
been around a long time
already. The difference
is that now it too is
available at more
reasonable costs. Dye
sublimation or 'dye sub'
is a significant option
for those wanting true
photographic quality.

shoot

Aleksandr Zadiraka is based
in Kiev, in the Ukraine. A
professional photographer he
shot 'Catherine' in his studio using
a 6Mp digital SLR and a
70–200mm f/2.8 zoom lens at
the shortest focal length. The
camera was set for 100 ISO
sensitivity and f9.5.

1/ The original
image.

2/ The final image,
'Catherine'.

enhance

The image was then taken into
Photoshop, where retouching
using the clone tool and healing
brush, plus creating the tone and
soft lighting took around two
hours.

enjoy

Images such as this often look their
best when they are continuous
tone. Dye sub technology offers
one such route. Aleksandr prints
his work for exhibition and personal
enjoyment.

> digital capture

> Photoshop

> clone tool

> healing brush

> dye sub print

allow the dye from the ribbon to fix on the paper. The paper moves each time across the ribbon for each colour, so you will find generally that dye sub is less quiet than ink jet output. The main benefit is that while an ink jet uses dots of ink, a dye sub print is continuous tone, just like a silver

halide option. Some are also simpler to run in that each time you load a set of paper and inks, they are matched so that there is enough ink for the number of sheets in the printing pack. No more running out halfway through the print run. The prints are dry once ejected from the machine and

laminated. Some dye sub models even have their own software for creating monochrome output. Dye sub prints have good stability and are water resistant. The other bonus with many printers is that they are able to output at a speed ink jet cannot match.

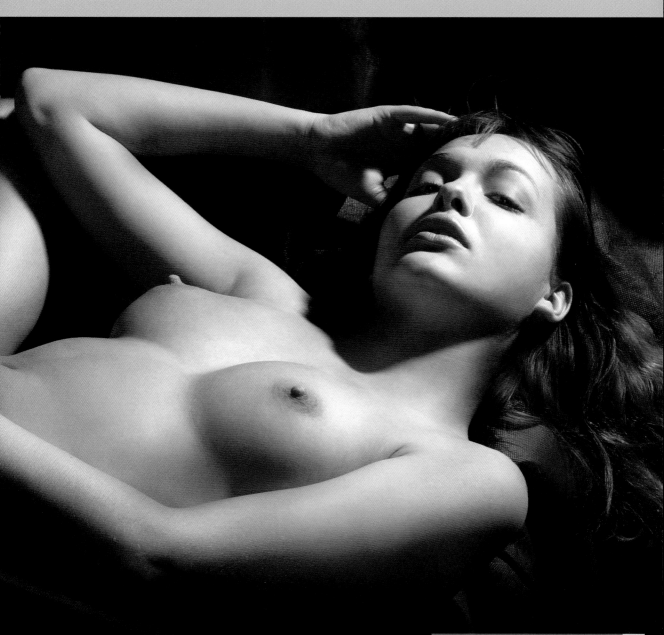

1

'I really like turning average colour images into black and white. The lines and shadows become more pronounced, and have more appeal to me, than colour often does.'

! Other programs may not offer the same route to producing the mirroring effect. For instance, with standard Photoshop programs this is not possible, although other effects such as rotation and distortion using transform and free transform under the edit menu are. With Photoshop you are able to use instead Image > Rotate > Flip Canvas Horizontal, to create the mirror-image effect.

adjusting your canvas

Claudia Kuhn is based in Woodstock, New York, USA, and describes herself as an amateur, but most certainly an enthusiastic photographer. Like many photographers she has found that changing an image's shape can be beneficial in adding impact.

shoot

'Twin Bridges' was created with a 5Mp compact digital camera. Taken at the Ashokan Reservoir, exposure was made at f/6.8, at 1/250th sec, using an ISO 400 sensitivity. A focal length of 21.4mm was set. As with many point-and-shoot cameras, an sRGB colour space was also used and maintained throughout the workflow. This is one of New York City's main reservoirs and the shot is made from one of the bridges that divides the reservoir into its upper and lower basins. Visually, the lines and repetition of the arches of the bridge appealed. Claudia took shots initially with just a UV filter fitted but was not entirely happy.

enhance

2

Photoshop Elements and ThumbsPlus Pro 6 are Claudia's manipulation packages. The first step was to get the image from the camera and opened in ThumbsPlus. Within this program general enhancements to effects such as contrast are made before taking the image into Photoshop. Here Claudia uses auto colour correction and auto contrast. ThumbsPlus also features a sepia effect filter that was added to the image.

It took around an hour working on this image. The main adjustments were in selecting the best crop, then duplicating the image. It was one of her first 'mirrored' images. Of course the time taken drops as you become more familiar with the process and tools used. Specifically, a crop was followed by cloning out tree leaves on the left side that hung over the bridge. There was also a dead tree in the water, so this too was cloned out. Next, the canvas width was doubled and the image moved to the left side. It was copied and pasted to the blank right side. To make things look more natural, the image was flipped horizontally using the transform options via Image > Transform > Free Transform.

Once this was selected this particular program prompts you to make this a feature on a new layer. Dragging the top left over to the right and vice versa, the image was flipped, providing the mirrored portion. Claudia then cloned over the small centre gap between them, before flattening the image.

> digital capture
> JPEG
> ThumbsPlus Pro 6
> auto colour correction
> contrast adjustment
> sepia effect
> auto
> crop
> clone tool
> canvas size
> cut and paste
> free transform
> clone tool
> archival ink jet prints

1/ The original image.

2/ The final duplicated image, 'Twin Bridges'.

3/ The canvas width was doubled and the image moved to the left side.

! **Extending the Canvas** Adding or even reducing canvas size can be beneficial on the way to creating something more exciting than your starting option. In Photoshop it is set using **Image > Canvas Size.** A dialog box appears into which we can type our desired value for change in either per cent, pixels, inches, mm, cm, points, picas or columns. (If you are reducing, type in a minus value.) The added area is in the colour of your current background colour. Click 'ok' and the change appears. We can also move the 'anchor' point of the original image so adjustment takes place from that new position rather than a central one.

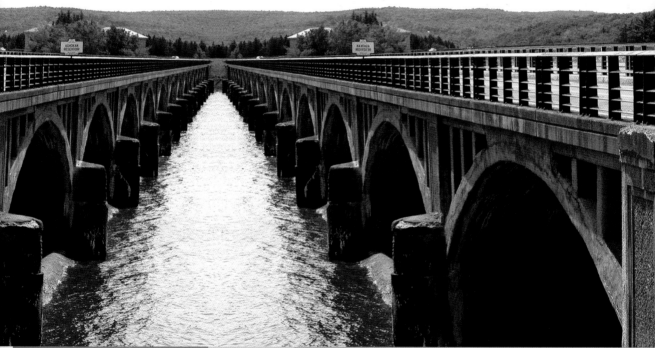

3 **canvas size**

Canvas Size

Current Size: 19.3M
Width: 25.4 cm
Height: 19.05 cm

OK
Cancel

New Size: 61.4M
Width: 43.34 cm
Height: 35.52 cm
☐ Relative
Anchor:

Canvas extension color: Background ☐

enjoy

Some of the photographer's work is shown in local galleries, but Claudia also sells prints and notecards at craft fairs throughout the year. Of course, like any self-respecting photographer, several works are on show at home also. Images are sold as 5 x 7, 8 x 10 and 11 x 14 inch prints, made on an ink jet printer using pigment inks featuring archival characteristics.

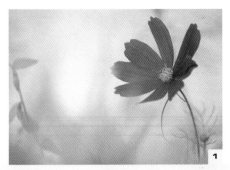

'Get as much of the final shot as you can in camera. The less post-production the better, as image quality decreases proportionately the more it is manipulated.'

! Always shoot or scan an image at the maximum resolution.

panoramic prints

The work of Darwin Wiggett is creative and varied as seen elsewhere in this book, befitting a professional photographer. He takes his own route to producing panoramic images as seen here.

shoot

Captured with a professional 35mm SLR and 70–200mm f4 lens, there was no preconceived idea behind this shot; it was simply 'an excuse to get outside and shoot some images'. It was taken in Darwin's own backyard in a flowerbed that borders his house. The emulsion chosen was a very fine-grained 100 ISO colour slide. He describes the result as nice, but pedestrian (1). From here the world of digital imaging took over to create something more memorable.

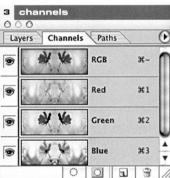

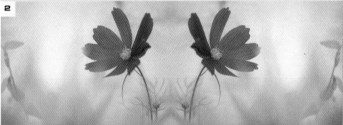

> 35mm capture
> scan
> Photoshop
> layers
> duplicate
> flip horizontally
> colour correction
> greyscale
> contrast
> RGB colour
> highlight selection
> hue/saturation
> feathering
> sepia tone
> TIFF file

enhance

Photoshop is Darwin's choice of manipulation software. The image was scanned in a top-of-the-line desktop unit, one that is renowned for its near drum-scan quality. Using layers, the image was duplicated and the copy flipped horizontally so the two could be placed next to each other (2). While this was more interesting, it lacked the vital element Darwin wanted; mood. As can so often be the case, it was monochrome to the rescue.

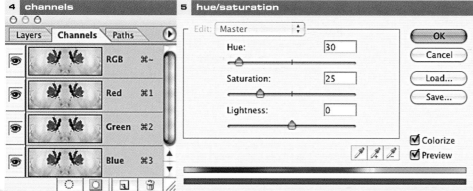

4 channels

Layers | **Channels** | Paths

	RGB	⌘~
	Red	⌘1
	Green	⌘2
	Blue	⌘3

5 hue/saturation

Edit: Master

Hue: 30

Saturation: 25

Lightness: 0

OK
Cancel
Load...
Save...

☑ Colorize
☑ Preview

1/ The original image.

2/ The panoramic colour image.

3/ The green channel gave dark flowers against a lighter backdrop.

4/ Converted back to RGB colour, the still mono tones all looked the same at this point.

5/ The sepia tone was created using hue/saturation adjustment.

6/ The final image after about 30 minutes spent in post-capture.

Looking at the individual colour channels, green provided a nice light background with dark flowers (3). This was then converted to greyscale and adjusted to increase contrast further. The image was then taken back to RGB colour via Image > Mode > RGB Colour so a sepia tone could be applied. At this stage all the channels looked similar (4) and clicking on to one of them and at the same time holding down the CTRL button on the PC keyboard allowed the highlights to be selected. The hue/saturation command was used next and by feathering the selection by 5 pixels, the sepia tone was created (5). This achieved the mood Darwin was after, without the need to adjust the flowers any further. In all, this was about 30 minutes' work post-capture.

enjoy

Darwin supplies most of his images to stock clients. This image was saved as a TIFF file.

6

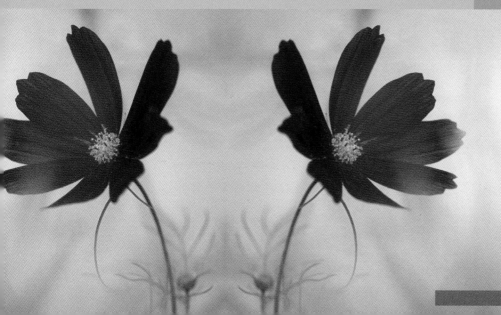

1

'My personal concern is with emotional honesty: trying my hardest to orchestrate an emotional response in the viewer that mirrors (or at least suggests) my own feelings for the subject.'

fine art photography

2 curves

Channel: CMYK

Input: 131
Output: 150

Fine Art photography sits at the pinnacle of good image-making. Primarily this is a monochrome world. Increasingly, collectors are investing in beautifully crafted images such as the examples here: good camera technique, advanced digital manipulation and high-quality traditional print output, mounted and framed. It is something we can all aspire to as a way to raise the standards of our work.

> 35mm film capture

> scan

> **Photoshop**

> **layers**

> **curves**

> **duplicate**

> **Kai's Power Tools**

> **gaussian glow filter**

> **layers**

> **curves**

> **layer mask**

> **magic wand**

> **clouds filter**

> **zoom blur filter**

> **layers adjustment**

> **TIFF file**

> **platinum/palladium print**

> **mount**

> **frame**

shoot

'Castle and Steps, Ireland' was created by Fine Art photographer and educator, Dan Burkholder. He is based in Dallas, Texas, USA, and exhibits his work internationally.

A top-of-the-line 35mm camera was used, fitted with a 20mm lens, and the shot captured one morning in light drizzle on the west coast of Ireland. The forced perspective of wide-angle optics is a strong attraction for Dan. Specifically, he likes the way compositions are forced into near, mid and distant planes.

enhance

Dan, like many, started shooting conventional monochrome film before moving to chromogenic emulsions then colour negative film in order to take advantage of colour filtration in Photoshop. He likes the tonal control as an alternative to filtering on camera with black-and-white film. A 35mm desktop scanner, always scanning in 16-bit mode at the highest resolution (4000dpi), converts images to the digital domain. Photoshop is his main package, but Extensis's pxl SmartScale is utilised for image interpolation, and NIK Dfine for digital noise control. When Dan looks at a RAW scan, he tries to judge why the image works or doesn't. If it's the latter, what steps should be taken? For 'The Castle and Steps, Ireland' he did not feel it needed to be combined with any other images, but it did need stylising to approach the drama and mystique he felt on the rainy, windy morning he originally took the image.

Opened in Photoshop then layers, the image became the 'background' layer. Opening the curves dialog box via Image > Adjustments > Curves, the control points were dragged creating a curved shape (2). The step wedge below the curve has the dark values on the left and the light values on the right which he prefers to the other way around.

Next, Dan duplicated the background, Layer > Duplicate Layer, naming it 'gaussian glow layer'. He likes to use names of the effect about to be applied. At the time the filter effect came from the popular Kai's Power Tools software package, but similar effects can be created in later versions of Photoshop. In this instance the gaussian glow filter was applied via Filter > Blur > KPT > Gaussian Glow. The settings were apply mode: multiply, style menu: blur, intensity: 15 and opacity set to full. This blurs the highlights and midtones, but has no effect on the darkest image tones. One of the most useful layer features Dan finds is to set how much any layer affects the layers below in the layer stack. In this instance making sure the gaussian glow layer was active, the opacity was lowered to

'A handmade object will always have a personal intrigue that a machine-produced object can't approach, even if they look similar.'

78%, slightly reducing the effect. Another layer option blended pixels in layers below. 'Darken' was chosen to enhance the mood created by the glow/blur effect. Adding a new adjustment layer, Layer > New > Adjustment Layer, curves was selected. Leaving opacity at 100% initially and the blend mode as normal, 'group with previous layer' was selected to avoid affecting all the layers

below, rather than just the layer immediately beneath. The curve was then adjusted.

The image was beginning to come together, but the gaussian glow effect had degraded important detail in the gravel, grass and stone areas around the foreground steps. To protect them they needed to be masked. A layer mask was created via Layer > Add Layer Mask > Reveal All. Several tools,

including the gradient tool (after creating a path and selection) and paintbrush, were used to create the mask.

The sky was next for treatment. With the background layer active, the magic wand tool was used to select the sky around the castle with a tolerance of about 30. Once the sky was selected it was copied via Edit > Copy. A new layer via the layer menu, Layer > New > Layer, was created and the copy pasted into it. This layer was called 'clouds layer'.

The sky layer had its 'preserve transparency' clicked to stop effects on it from affecting other areas such as the foreground detail. Now the layer was modified. The cloud filter was chosen and works around the set foreground and background colours. Dan finds the default black-and-white colours too stark, so before applying the filter they were changed. Clicking on the foreground colour, '75' was typed into the 'k' box of the C, Y, M, K values (3). A value of '7' was set for the background colour in the same way. A dark grey (75% dot) and a light grey (7% dot) for the foreground and background colours were now active. The effect was then applied via Filter > Render > Clouds (4).

These clouds were nice, but a greater dynamism was desired to help balance with the foreground steps. The zoom blur

1/ The original image scanned as 16-bit at 4000dpi.

2/ Curves were used to adjust contrast within the image.

3/ The foreground and background colours are changed from default settings.

4/ 'Clouds' filter for effect was added.

3 colour picker

Select foreground color:

- OK
- Cancel
- Custom

◉ H:	241	°	○ L:	41
○ S:	2	%	○ a:	1
○ B:	29	%	○ b:	-1

○ R:	73		C:	1	%
○ G:	73		M:	1	%
○ B:	74		Y:	1	%
			K:	75	%

49494A

☐ Only Web Colors

4 filters

Clouds	⌘F
Extract...	⌥⌘X
Filter Gallery...	
Liquify...	⇧⌘X
Pattern Maker...	⌥⇧⌘X

Artistic	▶
Blur	▶
Brush Strokes	▶
Distort	▶
Noise	▶
Pixelate	▶
Render	▶
Sharpen	▶
Sketch	▶
Stylize	▶
Texture	▶
Video	▶
Other	▶

| Digimarc | ▶ |

filter, Filter > Blur > Radial Blur, was applied with 20 as the amount set (5). The blur centre for the effect is crucial, so care should be taken as you drag your centre point down almost to the bottom of the box. Now the sky had drama but still needed a further contrast adjustment. This was done using adjustment layers.

A final contrast change for everything except the sky was made. By adding an adjustment layer as a curve, just below the cloud layer (and not grouped with the previous layer), Dan affected all except the sky layer.

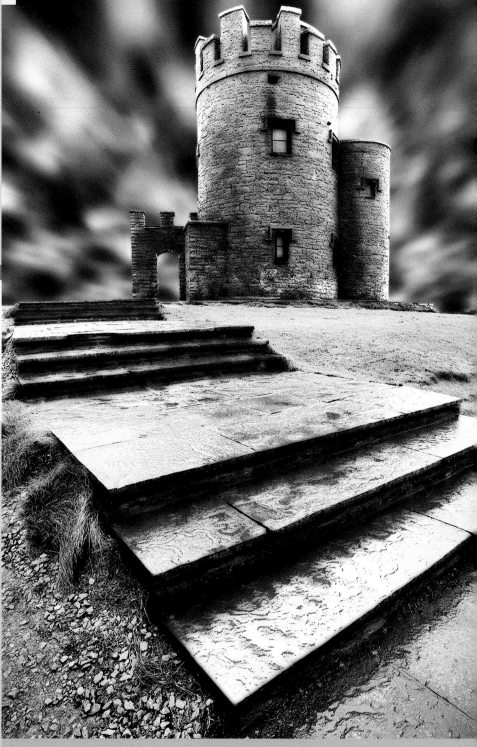

5 | radial blur

Amount 20

OK

Cancel

Blur Method:
○ Spin
● Zoom

Blur Center

Quality:
○ Draft
○ Good
● Best

Dan exhibits internationally in galleries and museums. This image has also been reproduced in magazines. Although he acknowledges that making ink jet prints is becoming a standard way of expressing the photographic image, he still loves working with traditional materials. He still values the chemistry and papers in a 'wet' darkroom for their longevity. Prints are platinum/palladium types with high archival permanence. 'Castle and Steps, Ireland' is a 9 x 6 inch image, with a matt surround and final dimensions of 20 x 16 inches. His latest work is 'pigment-over-platinum', in which he combines digitally applied pigments with hand-coated platinum/palladium. 'The final look is unique as the subtle colour blends with the browns and blacks of the hand-coated precious metals.'

5/ The radial blur filter.

6/ The final eye-catching result.

7/ The 'Egyptian on Pier' image is a composite of images. Dan photographed the Egyptian in Alexandria, Egypt; the pier and boats were shot in Holland. He is repeatedly drawn to symmetry, so this combination was natural for him from a compositional point of view. He recently sold two 12 x 18 inch platinum/palladium prints of this image to two different galleries. This was a fairly straightforward composite. The Egyptian was pasted on to the pier image, as were the boats from another image. This image was created in a version of Photoshop before we had layers, so was a much more demanding way to work. The shadow for the Egyptian was created using his shape as a starting point. It was inverted and distorted to create the area to darken for the shadow. As shadows are both darker and lower contrast than surrounding areas, a curves adjustment to open up believable shadow tonality was made.

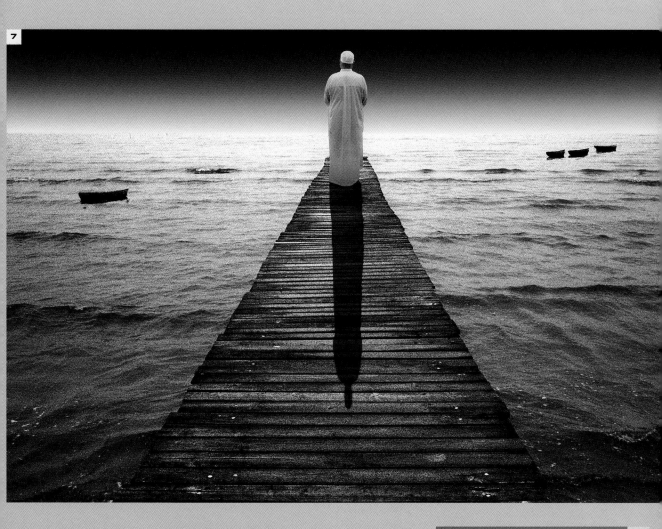

7

appendix

'Buachaille etive Mor' by Tony Perryman.

This image was created on 35mm slide
film. It was taken into the digital realm by
scanning at 1280dpi, then into
Photoshop. The hue was adjusted and
then the lasso tool used to select the left
and right areas at the top of the image.
These were feathered by 140 pixels to
achieve a soft gradient. Levels were then
used to darken those areas. The dodge
and burn tools lightened and darkened
areas of the image, followed by the
unsharp mask, set approximately to
amount 90%, radius 2.0 pixels, and
threshold 1 pixel.

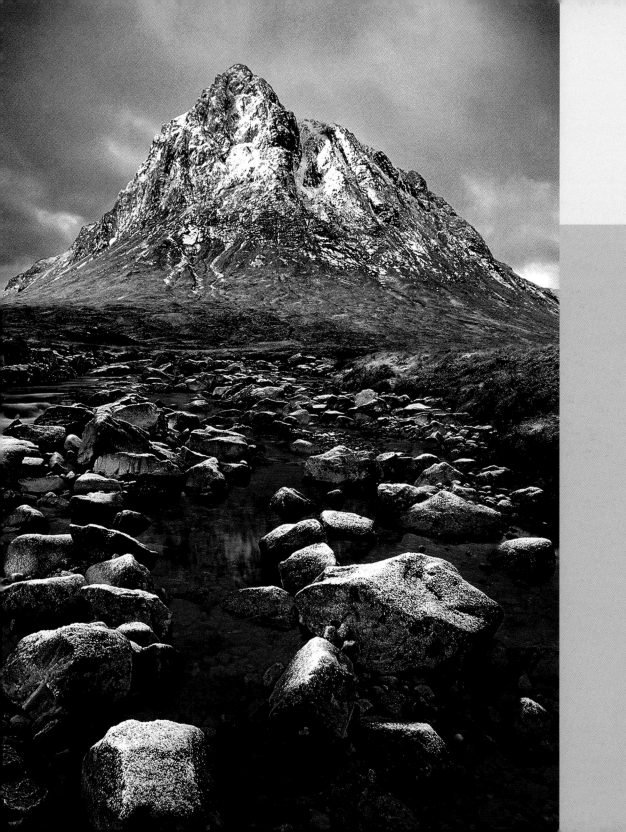

glossary

Actions
A series of adjustments and resulting effects made in a sequence. This saves time with repetitive tasks and aids the workflow.

Aliasing
An effect where jagged edges between pixels show when they should be seen as straight or curved. An anti-aliasing filter lessens the effect, as does software using an anti-aliasing process. This reduces contrast between adjacent edge pixels and the resulting jagged look. It requires more USM to counteract.

Analogue
A continuous signal of information. In the case of film this gives continuous tone. Digitising images results in a non-linear or stepped series of information.

Bit Depth
The bit depth indicates the number of gradations of tone or colour in an image. The higher the number the greater they will be.

Black Point
An eye dropper tool selects a specific pixel brightness level and changes that to a level of zero (black).

Brightness/Contrast
A basic but common adjustment made to digital images. Best use may come from working on a specific area using adjustment layers or similar.

Canvas
This refers to the area of the image that can be worked upon. You can extend or reduce a canvas to change the shape of an image. This is useful for composite images such as when creating panoramas.

Cloning Tool
A popular tool also called the rubber stamp. Used for copying one area of an image into another.

Colour Picker
A means to select a desired colour.

Colour Space
The name given to the location of specific colours in an image based on a theoretical model. Different colour spaces have a larger or smaller gamut to each other. sRGB is smaller than Adobe 1998 for instance, the former more suited to monitor viewing than print reproduction.

Colour Temperature
Measured in degrees Kelvin (K), colours are registered differently by camera sensors and film compared to our eyes and brain. This results in unnatural looking colour with a tendency to warmth or coolness with different light sources, and sometimes other colour 'casts'. A manual or auto white balance measurement is best used at the time of capture to overcome this. Post-capture adjustment can also be made in many instances, especially with RAW data.

CMYK
An abbreviation for Cyan, Magenta, Yellow and Black. These 'subtractive' colours are used to produce colour in images printed on paper including silver halide, ink jet and magazine reproduction.

Feathering
Some selection tools allow parameters to be set to blur edge pixels in an image and smooth the differences between pixels. Also the term used in studio work to describe the edge lighting effect of a softbox fitted over a studio flash head.

File Format
The data that makes up an image can be created in a number of ways. Each is referred to as a file format. The more common ones used in digital imaging are JPEG, TIFF and PSD.

Filter
An on-camera attachment or software process to modify or enhance an image.

Gamut
The range of colour that can be displayed or printed.

Greyscale
The term for black, white and grey shade images absent of colour.

Healing Brush
A variation on the cloning tool that helps keep tone and texture looking natural.

Hue/saturation
A common means to adjust colours and their purity and intensity. In mono, desaturating an image gives it a greyscale look. Reintroducing colour adds toning.

Interpolation
The term used to describe adding pixels into an image, created by sampling information from pixels nearby. Also called resampling. Bicubic is best for most images.

JPEG
A very popular file format that uses compression to throw away data to keep the file size down and speed up writing times. JPEG stands for Joint Photographic Experts Group, the combination of companies who originated the idea.

Lab Colour
A flexible means to work with colour and luminance. The latter is separated into its own channel with colours placed in two others. Any channel can be adjusted without affecting the other two.

Layers
Fundamental to working on complex images, each layer allows specific parts of an image to be adjusted alone. Other areas are left unchanged. Flattening layers at the end combines them for the final image.

Levels
A straightforward way to adjust image contrast and tonal range.

Platinum Print
One of the traditional types of paper print, desirable for its longevity and tonal range and used by Fine Art photographers. Small amounts of the precious metal are used, helping to give it its distinctive look.

RAW Data
Basic information gathered by a digital sensor and processed by software. This can be adjusted post-capture in the most flexible ways. It is lossless, but RAW files remain considerably smaller than TIFF files. A RAW file is our 'digital negative' and should be treated as such.

Resampling
See Interpolation.

RGB
The colours of red, green and blue are used to create images in camera and on a monitor.

TIFF
Stands for Tagged Image File Format. This lossless option offers a stable image file that can be opened by most imaging applications. Creating TIFF files in camera takes the longest time and takes up the most space however.

USM
Unsharp Mask is a means to increase and decrease apparent sharpness by adjusting contrast between pixels.

White Point
An eye dropper tool is used to select pixels of a desired brightness value and change them to one of 255 (white). This can help remove a colour cast in addition to brightening an image.

Anton Falcon, a professional photographer, took this image, 'Don't Go Chasing'. He used a digital SLR and professional level lenses.

contacts

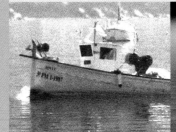
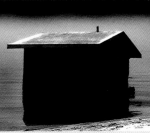

Bruce Aiken

Art collage gave Bruce the inspiration to experiment in various fields of visual creativity. He is a designer who, amongst other things, works on the books in this series. An enthusiastic photographer also, he has made the switch to capturing mostly with a digital SLR, although he still has film cameras at his disposal. He has been commissioned over the years for numerous works of painting, writing, cartooning and photography.

pages 76–77, 114–115

www.aikengraphics.co.uk

Jeff Alu

The work of digital photographer Jeff Alu has a unique high-contrast feel to it. Based in Irvine, California, USA, he is widely published. He finds mystery, power and intensity in working with monochrome that simply is very difficult to capture using colour. Today that means digital capture then manipulation, even though he has lots of traditional darkroom experience.

pages 124–125

www.animalu.com/pics/photos.htm

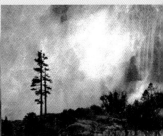

John Clements

John is a professional photographer based in Essex, England. Widely versed in numerous forms of photography, he also writes about imaging, and is a technical contributor to the British Journal Of Photography. For AVA Publishing John has written A Comprehensive Guide to Digital Landscape Photography and An Intermediate Guide to Digital Photography. A Comprehensive Guide to Digital Close-Up Photography will follow this book.

pages 15, 33, 38–41, 58-59, 94–97

www.johnclementsimaging.co.uk

Nigel Danson

Nigel has a passion for monochrome images. Based in Manchester, England, he is a dedicated enthusiast who shoots on both film and digital SLRs. Monochrome images are to him often more powerful at capturing a scene and the feelings at the time of the shot than colour images. His images have been shown at a few small exhibitions.

pages 56–57

www.nigeldanson.co.uk

 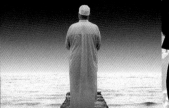 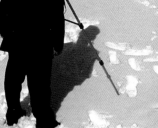

Connie Bagot

A semi-professional photographer from Ellis, Kansas, USA, Connie likes her images to have a story or message beyond just being a realistic capture of a particular subject or scene. To her, black-and-white images seem to allow more room for the imagination, often conveying a mood or feeling better than in a colour image. Connie uses digital capture and, like many, Photoshop for detailed post-production.

pages 90–93, 110-111

Dan Burkholder

A Fine Art photographer and educator, Dan is respected for his technique and fine imagery. Based in Dallas, Texas, USA, he also travels internationally giving lectures. Combining film capture with digital manipulation he takes older proven ideas and works them into the modern image-making workflow. Platinum/palladium prints give a lasting image with their own unique tonal qualities.

pages 132–135

www.danburkholder.com

Jon Bower

Jon's work has been featured in a number of AVA's titles and he consistently provides eye-catching but natural imagery. While an environmental scientist, his work has allowed him to become a successful photographer too, with his work selling through stock agencies. This needs high quality originals, in Jon's case film and detailed post-production to tidy up various aspects. He is based in Oxford, England.

pages 31, 51

www.apexphotos.com

Tess Campbell

Tess lives in Wisconsin, USA. Totally self-taught during the last five years in both photography and photo manipulation, she believes a camera points both ways, so that a truly successful image says as much about the author as it does about the subject. Shortly after discovering digital photography, Tess found online photo critique sites. Infrared photography captured her imagination and with digital infrared being in its infancy she learned by much trial and error.

pages 108–109

www.shuttercity.com

 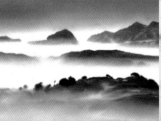 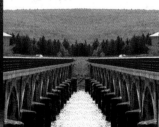

Mary Ella-Keith

Full-time artist and photographer, Mary now shoots all pictures digitally. She appreciates monochrome images for their elegance, timelessness and impact. Often her photographs are reproduced using a duotone option, giving toning effects. To Mary, imagination is as important if not more so than the latest hardware.

pages 88–89

www.MEBKphotoart.com

Anton Falcon

A professional photographer from San Francisco, California, USA, Anton Falcon tackles what in digital times is more controllable than ever: infrared photography. This is a fascinating aspect to monochrome imagery and one which many more digital photographers will tackle because of the control at their fingertips. Anton outputs prints for both his own enjoyment and exhibition, selling most images online.

pages 60–61, 66–67, 138

www.infraredgallery.com

Juergen Kollmorgen

Using many means of capture from large format film to digital compacts, Juergen is first and foremost a landscape photographer. He sees the digital possibilities available today as endless opportunities. He certainly prefers the digital darkroom to a traditional one for aspects such as retouching or tonal adjustments. For the creation of digitally-stitched panoramas he appreciates digital controls, which allow adjustment to perspective and a controlled amount of distortion.

pages 42–43, 106–107

www.lightandpaint.com

Claudia Kuhn

As an amateur photographer and enthusiast, Claudia, who is based in Woodstock, New York, USA, likes turning what may be an average colour shot into black and white. The lines and shadows become more pronounced, having more appeal. Claudia spends any spare time she can find taking pictures.

pages 128–129

www.pixtopics.com

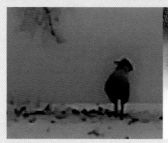 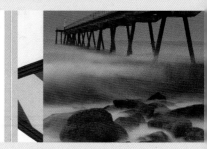

Miguel Lasa

Miguel Lasa is based in Hartlepool, in the county of Yorkshire, England. He describes himself as a 'digital artist', an apt and sensible term for modern image-makers. His work in this book retains a traditional feel to it, not extreme manipulation on face value; often the sign of good post-capture manipulation.

pages 4–5, 52–53

http://miguel-lasa.smugmug.com

Louis McCullagh

A professional photographer based in Belfast, Northern Ireland, Louis finds monochrome a refreshing change to the multicoloured world we live in. For him it demands strong composition and precise exposure control. He finds it useful in portraits for those with less than perfect skin. His style is to leave the finished image looking as untouched and natural as possible.

pages 48–49

www.respectphotography.com

Heather McFarland

Heather comes from Gaylord, Michigan, USA, and is a professional photographer. Her work sells online and through local Fine Art dealers. She is particularly drawn to images with strong graphical lines and contrast for her monochrome work.

pages 10–11, 14, 72–73

www.hkmphotos.com

Fernando Pegueroles

Barcelona, Spain, is home to Fernando, an advanced but amateur photographer. He likes to create landscapes in special light, often pleasant and peaceful in mood. But if that's not possible, he still looks for something of an unexpected surprise in the shot. He uses the same filters to adjust contrast as he would with film cameras even though he now shoots digitally.

pages 98–99

http://perso.wanadoo.es/fpegueroles

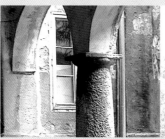

Mirko Sorak

Mirko is an amateur photographer who lives in Zagreb, Croatia. This wonderful 'old' city is a source of inspiration for his fascination for architecture. He finds monochrome an ideal platform for showing this off to the full. Considered exposure followed by sensible post-production is the basis for his work.

pages 16–17

www.mirko-sorak.com

Walter Spaeth

Between 1990 and 2000, Walter Spaeth won over 30 awards for his photography and digital post-production. Widely exhibited and published, his work shows imagination and advanced technique. He is based in Nehren, Germany.

pages 18–19,102-103

www.photopage.de
www.artside.de

Wernher Swiegers

Based in Stellenbosch, South Africa, Wernher is an amateur photographer. He acknowledges he is still learning and experimenting, trying out different styles and subject matter, having bought his first SLR only a few years ago, then going digital more recently. He prefers the obvious advantage of immediate results.

page 7

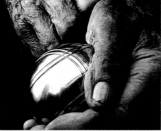

Mark Peisachovich

Mark Peisachovich is a photographer working in Israel as a software developer. His photography was an old hobby that has now turned into a passion. He spends a great deal of his spare time on photography and all its different aspects: shooting, learning, editing etc. He was self-taught and has honed his skills through shooting thousands of photographs over the years.

Cover image

www.markello.net

http://markello.photosight.ru

Tony Perryman

Tony Perryman is an enthusiastic photographer based in Harlow, Essex, England. His work is impressive and featured throughout this book. Some images originated on film, but many are now captured digitally, followed by subtle but effective manipulation. He sells occasional work through a local gallery.

pages 25, 55, 62–63, 74–75, 104–105, 137

www.craftyframes.co.uk

Phil Preston

Phil calls himself a keen amateur, but his work is of a higher standard than that. Now he captures images digitally and uses a number of programs post-capture. Monochrome for him is great for images that have strong composition, conveying mood and atmosphere. It also suits the range of different subject matter he tackles such as landscapes, portraits, architecture, still lifes and abstracts.

pages 34–37, 68–71

www.digital-fotofusion.co.uk

Felipe Rodriguez

Describing himself as an enthusiastic amateur, Felipe, based in Seville, Spain, has been inspired by many famous monochrome photographers such as Ansel Adams, Cartier-Bresson and Robert Capa. He tries to spend as much time as he can capturing images with a digital SLR.

pages 22–23, 28–29, 84–87

www.beatusille.net

Jenny Taylor

Professional photographer and artist, Jenny hails from Austin, Texas, USA. Using both digital capture and medium format film, it is the absence of colour that draws out other aspects in an image. That means texture, shape and light become for Jenny more profound. She also appreciates how black-and-white images set mood, while separating the image from real life.

pages 118–121, 122–123

www.exposed.info

Stewart Whitmore

Based in Burbank, California, USA, Stewart sees himself as an enthusiast. He rarely outputs hard copy but tackles online photography contests with enthusiasm. He keeps practising and experimenting, trusting his instincts. As such, while he cannot define exactly what it is, he prefers many images in mono compared to colour. As for an approach, that follows an artistic instinct and if the light is falling in a way that he finds interesting, then a shot is taken of the subject.

pages 46–47

www.digitalphotocontest.com/ profile.asp?pid=21981

Darwin Wiggett and Anita Dammer

Part of a husband and wife team, 'Natural Moments Photography' is the result. Its creations sell through various stock agencies. Darwin feels that, as with any type of photography, digital capture is first about light and understanding it. Techniques and then manipulation should only work to enhance the mood of the light captured in camera.

pages 20–21, 80–83, 112–113, 130–131

www.portfolios.com/NaturalMo mentsPhotography

Aleksandr Zadiraka

A professional photographer based in Kiev in the Ukraine, Aleksandr often finds his images work best with the absence of colour, as that otherwise gives an unnecessary feel and character. He has his own studio and sells his work in exhibitions.

pages 126–127

www.zadiraka.kiev.ua

acknowledgements

I am very pleased to be involved with AVA Publishing and their titles. As with any book, this one is the result of a team effort, with each link in the chain necessary for the project to be finished. My gratitude therefore goes to Brian Morris of AVA who sanctioned the idea, and Laura Owen who painstakingly worked through my text and added the gloss to the finished work. However, there were other indispensable people in this project. Bruce Aiken's designs look modern and clean, and his own creative background is rewarding for an author to tap into. Likewise Sarah Jameson's picture research was tireless, often coming up with new and better images to consider when the author felt things could be improved.

Finally no book like this is possible without the vast number of photographers, from the amateur to professional, who have enough passion about their art to create the wonderful images we show you. My thanks to them not only for this, but also for their kind effort in supplying background information when asked for. I hope you enjoy this book as a testament to this particular team's efforts.

Best wishes,
John Clements